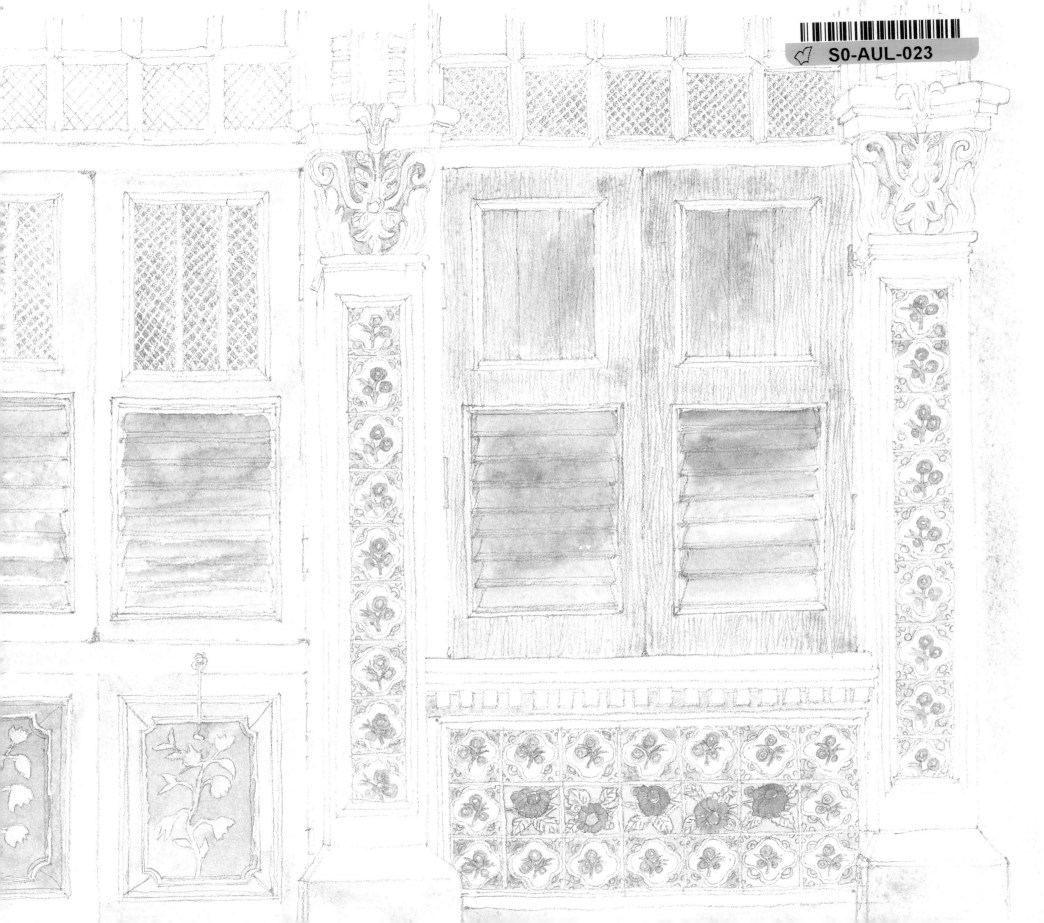

Singapore Sketchbook

ARTIST'S ACKNOWLEDGMENTS

The original book is the culmination of a decade-long love affair with Singapore's architectural heritage. As a newly arrived art director off the plane from Europe in the mid 1980s, I was enchanted by the style and scale of the island's old buildings. Soon I was spending many weekends painting them. As I continued to sketch and paint over the years, I was also witness to Singapore's conservation programme. Gradually the idea of doing a book that would record the many changes took shape. Along the way, many people generously gave their support.

Now we have moved on to book two, as since 1995 there has been even more restoration. I still give thanks to the Singapore Tourism Board and the Economic Development Board for their continuing interest and encouragement, especially STB's Chairman Edmund Cheng and Pamelia Lee. Also Richard Helfer, Chairman and CEO of Raffles International, has been a keen supporter of my work as well.

In putting the second book together, I am indebted to my publishers Didier Millet and Charles Orwin who were positive from the start.

Then came my friend, writer Gretchen Liu, who has written the text with such knowledge and depth. Our joint efforts have, I hope, produced an unusual and enjoyable record of restoration. To Tim Jaycock, editor of the first book, and Jacqueline Danam, editor of this second book, thanks are due for their endurance with the fax machine, the main means of communication with my studio in Spain, and for checking everything so thoroughly.

Thanks must also go to Jayne Norris and Robert Henley for their kind hospitality during my visits. Finally, I am very grateful to the friends and acquaintances who allowed me to paint their homes for the book or allowed us to reproduce earlier works. Ronald Pederson of the Danish Seaman's Church; Raffles International for Clarke Quay; Emerald Hill resident Richard Helfer; Albert Lim for his house at No. 12 Koon Seng Road; Alexandra Park residents Jayne Norris and Robert Henley; Esme Parrish; and Mr and Mrs P Sanderson for showing me Winchester School and the Botanic Gardens.

Artwork © Graham Byfield, 1995, 1999, 2001
Text © Gretchen Liu and Graham Byfield, 1995, 1999, 2001

Design and typography © Editions Didier Millet, 1995, 2001

First published 1995
Reprinted 1996 (twice), 1997, 1998, 1999 (twice), 2000
New revised edition December 2001, reprinted 2004

Published by **Archipelago Press**,
an imprint of
Editions Didier Millet,
121 Telok Ayer Street #03-01
Singapore 068590
www.edmbooks.com

ISBN 981-4068-40-3

Editors: Tim Jaycock, Jacqueline Danam
Designers: Tan Seok Lui, Norreha bte Sayuti
Production Manager: Sin Kam Cheong

Colour separation by Colourscan Co. Pte Ltd
Printed in Singapore by Star Standard Industries (Pte) Ltd

Singapore Sketchbook

Paintings by GRAHAM BYFIELD
Text by GRETCHEN LIU

ARCHIPELAGO PRESS

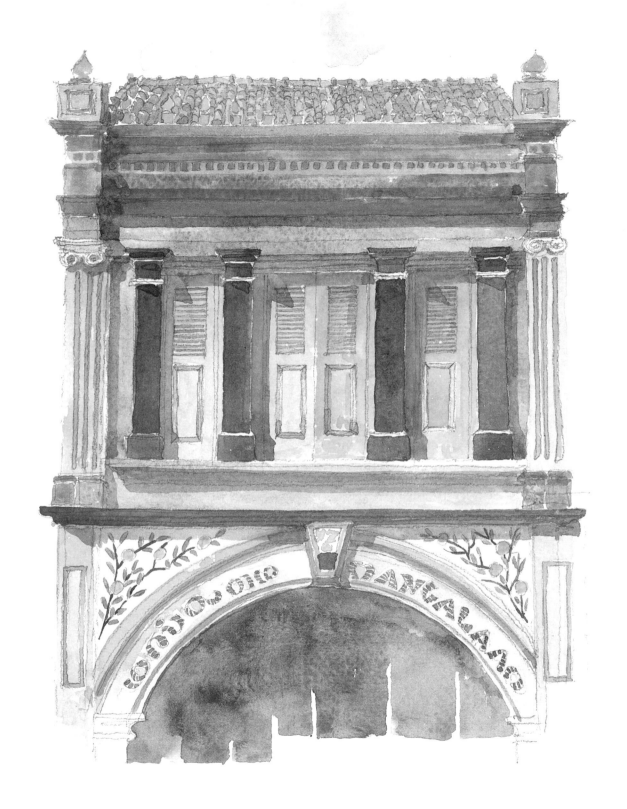

No.6 Upper Dickson Road, Little India

Contents

Introduction

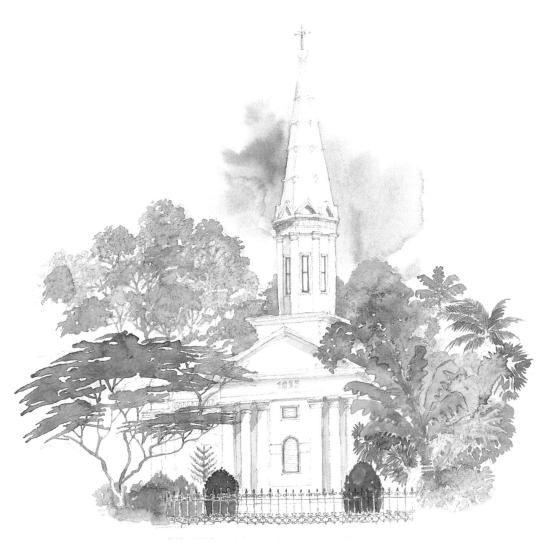

Neither the passage of time nor the urbanisation of its surroundings has diminished the dignity of the Armenian Church. One of Singapore's oldest buildings, it first welcomed worshippers in 1836.

Singapore Sketchbook was initially conceived as a celebration of old Singapore and the restoration of the many wonderful pre-war buildings that give the island its unique and much-admired character. When the first edition appeared in 1995, large areas of the old city were in transition. The process of restoring individual building, streetscapes and even entire districts had begun in earnest. Spruced up shophouses incongruously shared party walls with still dilapidated neighbours. Shabby streets were in the midst of being reshaped by young architects and designers. Several national monuments were being assigned new uses. There was a sense of experimentation and excitement as old buildings made their re-debut. Statistics tell part of the story: by early 1995 some 5,319 buildings had been gazetted conservation properties; of these only 1,200 had been restored. By 2000, of some 5,600 conserved heritage buildings, well over half had been restored.

Since then the old city has continued to evolve. After the initial burst of activity the changes have been more gentle and consistent. Certain approaches have, perhaps, been more successful than others. But the past and the present firmly, respectfully, coexist and will happily continue to do so in the years to come.

The flourishing of such a large stock of old buildings in a small, land-scarce city state, where rapid change and an unsentimental approach to the past have been the norm is but the latest chapter in the story of Singapore's development, a story that commenced almost 200 years ago with the establishment of a British trading centre on an island inhabited mostly by Malay fishermen living along the coast.

A MODEST BEGINNING

Modern Singapore is a young city. Like other former British colonial ports – Bombay, Calcutta, Hong Kong, Sydney and Shanghai – it flourished where virtually nothing had existed before. At its founding it was largely the idea of one man, Sir Thomas Stamford Raffles, the visionary British East India Company official who sailed into the Singapore River and signed a treaty with the local chieftain, Temenggong Abdul Rahman of Johore, on 30 January 1819. This first treaty granted a small strip of land along the coast to the British traders. A second treaty, signed between the Sultan and the East India Company in 1824, handed over the entire island.

Raffles' objectives were free trade and the extension of British influence in the East. His mission was to establish a strategically located British "factory" (the old-fashioned word for trading post) in the Malacca Straits.

Raffles never lingered, making only three visits to Singapore between 1819 and 1823, which added up to less than a year's stay. Yet he had a profound impact on the way the town area developed. In 1822, Raffles returned to discover a swelling population and urban chaos instead of the neat "pride and Emporium of the East" he had envisioned. With the help of a committee of prominent residents and Garrison Engineer Lt Jackson he devised a town plan – the imprint of which is still discernible today.

The cornerstone of this plan was the division of the town into separate districts, each with its own function. The seat of government was allocated the flat north bank of the Singapore River while the commercial district lay along the south bank. Although wealthy merchants of all races were encouraged to trade side by side, and could live according to their means wherever they liked, the majority of the population was settled into segregated communities. Thus the Europeans were directed to the area adjacent to the government district. The Chinese who, Raffles rightly anticipated, would compose the largest single group, relocated south of the river in what is today's Chinatown. The Sultan and his followers were provided land in Kampong Glam and here Arabs, Bugis and other Muslims were encouraged to settle.

The plan was remarkably detailed. It provided for education and religious buildings, a network of roads and streets of specified widths to be laid out at right angles, and the subdivision and sale of uniform plots of land. It also specified a linear arrangement of commercial buildings and linked shophouses of specified widths and uniform facades. A five-foot way, an arcaded covered passageway, was introduced "for the sake of regularity and conformity" as well as weather protection. Buildings were to be constructed of brick, with tiled roofs and solid foundations.

AN AIR OF PERMANENCE

These measures soon gave rise to the attractive townscape captured in early engravings. Such scenes owed a great deal to one other individual, George Drumgoolde Coleman. An Irishman, Coleman had studied architecture in Dublin, travelled extensively in Europe and was well versed in the vocabulary of classical architecture by the time he arrived in Calcutta in 1815. He first

visited Singapore in 1822, and was involved in several of the projects commenced by Raffles. He returned to live in 1826 and for the next 15 years was engaged by the government to carry out topographical surveys and to plan roads and bridges.

Coleman also maintained a flourishing private practice as architect and contractor. He was responsible for many of the houses commissioned by the Europeans as well as several churches, a school (Raffles Institution) and commercial projects. On the street that even today bears his name he built his own grand, now long-demolished, residence. Coleman died in Singapore in 1843 but his legacy endured for decades. He set a high standard for architectural work with his elegant, airy style that conformed to English traditions but made concessions to the tropical climate.

One benchmark of Singapore's success was the flourishing of religious buildings. To replace their wood huts, the various communities commissioned permanent places of worship – including the Armenian Church (1835), the first St Andrew's Church (1836), Thian Hock Keng Temple (circa 1842), Hajjah Fatimah Mosque (1846), the Sri Mariamman Temple (circa 1843) and the Jewish synagogue in Synagogue Street (1845).

Visitors often expressed approval of the town's appearance. John Cameron, for example, observed in *Our Tropical Possessions in Malayan India* in 1865: "The town...being remarkably compact, the country may be said to come right up to its walls. There are none of those intermediate half-formed streets, with straggling houses here and there, separated by blank, barren open spaces, which so often disfigure the outskirts of a town. Where the town

The heart of the city. The old stones of an empire cluster around the Padang, the green sward as old as the city itself, all dramatically framed by the skyscrapers of the financial district.

Back alley staircases are also subject to restoration requirements.

ends, the country commences; indeed it would be difficult for a price of ground to remain long desert, for nature would soon crowd it with her works, if man did not with his."

By 1860, the town still extended in very few places more than a kilometre and a half (about a mile) from the beach, even though the population had doubled, from 35,000 in 1840 to 81,000 in 1860. The increased density was felt most in the ethnic quarters but even the European residential area around Beach Road and the Esplanade was considered somewhat crowded. Many of the large bungalows were converted into boarding houses and hotels when their owners moved to the new residential districts around River Valley Road, Killiney Road, Orchard Road, Claymore and Chatsworth. These new districts emerged on land cleared for nutmeg, gambier and pepper plantations. By the time the nutmeg trees succumbed to a devastating blight in the 1860s, land had been cleared right across the island.

THE BOOM YEARS

In 1867, Singapore's status changed from that of an East India Company outpost to a British colony and seat of government of the Straits Settlements. The move underscored the island's strategic importance, and it was not long before the first Governor of the Straits Settlements was ensconced in the newly built Government House (the Istana).

These political events coincided with innovations in transportation. The opening of the Suez Canal in 1869 prompted novelist Joseph Conrad to write that it was, "like the breaking of a new

dam, (and) had let in upon the East a flood of new ships, new men, new methods of trade. It changed the face of the Eastern seas and the spirit of their life". Equally important was the commercial viability of steam navigation. Coal-fired steamships dramatically reduced travelling time on the world's oceans. Singapore became one of the world's great coaling stations, "the great junction where...all who travel must stop and see what a marvel of a place British energy has raised from the jungle in half a century," wrote Eliza Scidmore, an American traveller in the early 1890s.

The boom years continued, with only a few short interludes, from the 1870s until the Great Depression in the 1930s. Around the turn of the century, they were further fuelled by the wealth created from the world-wide demand for rubber for the nascent automobile industry and tin for the canning industry, and for which Singapore was the principal outlet and commercial port.

Singapore's new status required suitable stones of empire and new public buildings steadily appeared – from the Government Offices at Empress Place (1864-65) to the Supreme Court (1939). An impressive new generation of banks and commercial buildings also made their appearance. As it turned out, many of these lasted barely half a century as they were, in turn, replaced by yet more modern structures.

Up to the 1880s, many of the buildings were the handiwork of skilled craftsmen and quasi-professionals who relied on traditional building methods. By the turn of the century, the city offered sufficient work to sustain a more sophisticated architectural practice. The introduction of technical innovations such as

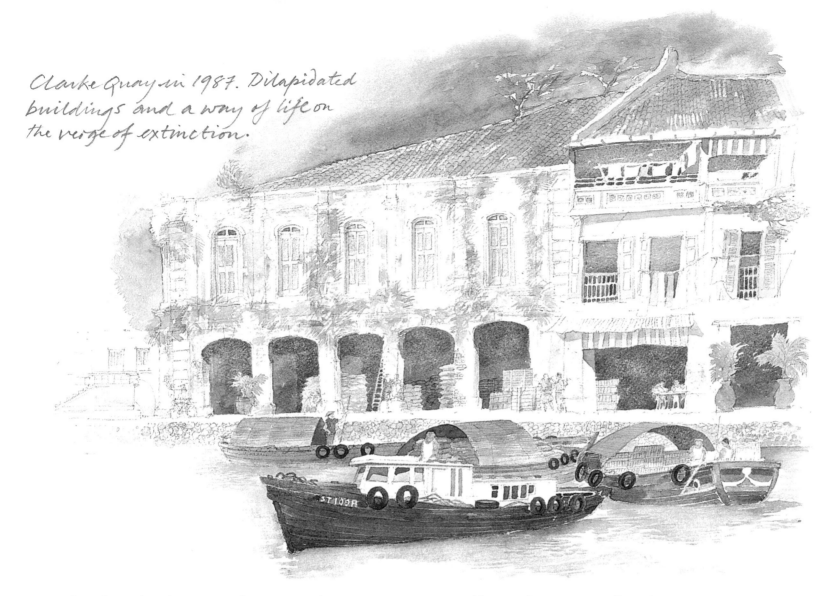

Clarke Quay in 1987. Dilapidated buildings and a way of life on the verge of extinction.

structural steel, reinforced concrete, electricity, modern sanitation and lifts also required a new level of expertise.

Many large commissions were given to the firm of Swan & Maclaren and its leading designer, Regent Alfred John Bidwell. Bidwell arrived in Singapore in 1895 with excellent credentials: the honours list for design at his London school; a stint with the London County Council and in private firms; and a stint with the Public Works Department in Selangor, Malaya. His surviving and much-admired works include the Main Building of Raffles Hotel (1899) as well as the Bras Basah Wing (1904), Stamford House (1904) and St Joseph's Church (1913).

Singapore's growing prosperity coincided with the last unsettled decades of the Qing Dynasty. As word of economic opportunities spread, thousands of Chinese immigrants arrived in search of a livelihood. Many of these poor and indentured labourers crowded into Chinatown's shophouses-turned-tenements. The population swelled with immigrants from India, the Middle East and elsewhere in Southeast Asia as well, and by 1871 it stood at

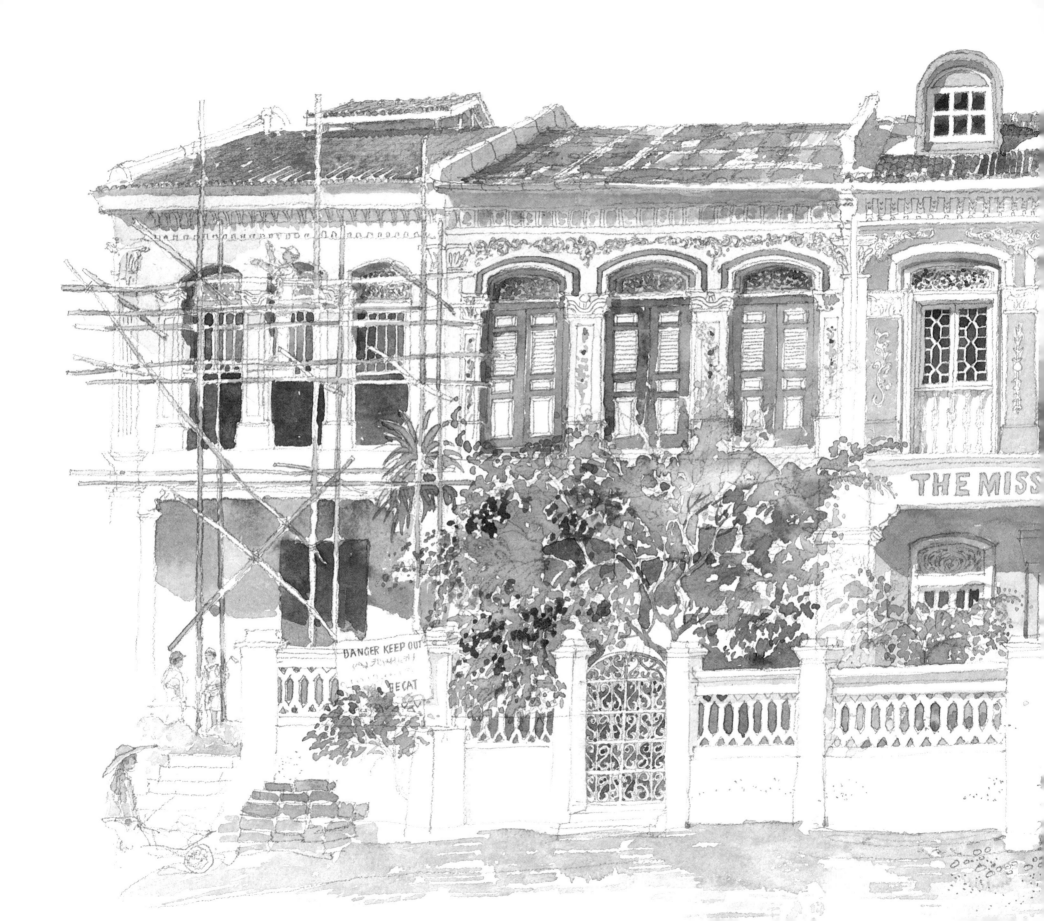

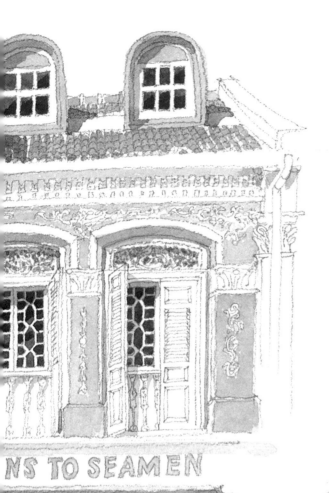

Along River Valley Road the Missions to Seamen building was an early restoration effort. Neighbours are now catching up.

NS TO SEAMEN

97,000; by 1900 at 228,000 and by 1921 at over 418,000.

These years saw tremendous changes in transportation. Human-drawn rickshaws were introduced as public transport in 1881. Motorcars made their appearance, rising from 842 in 1915 to 3,506 in 1920 and causing acute congestion.

As land in the central area became more expensive in the 1920s, the suburbs rapidly expanded. Malay communities were scattered up and down the coastline, stretching from Changi to Jurong. From High Street and Serangoon Road, the Indian community occupied the railway and port areas at Tanjong Pagar and Keppel Road and the naval base in Sembawang. Affluent Chinese inhabited newly built terrace houses near town or bungalows along Bukit Timah Road. The Europeans had moved further out to Tanglin, Holland Road and the military bases at Changi, Alexandra, Ayer Rajah and Seletar.

During the Great Depression and Japanese Occupation, the rate of building sharply decreased whilst the population steadily increased. Thus although the city survived the war with relatively little physical damage, post-war overcrowding, unemployment and lack of proper housing took a more serious toll. Even after the colony had regained its economic strength in the early 1950s, Singapore gave the new arrival an overwhelming impression of tattered buildings and faded houses.

Post-war housing conditions for the majority were remarkably substandard. In Chinatown, for example, shophouses were intensively sublet and chronically overcrowded. On the periphery of the city, squatter areas proliferated. To prevent landlords from exploit-

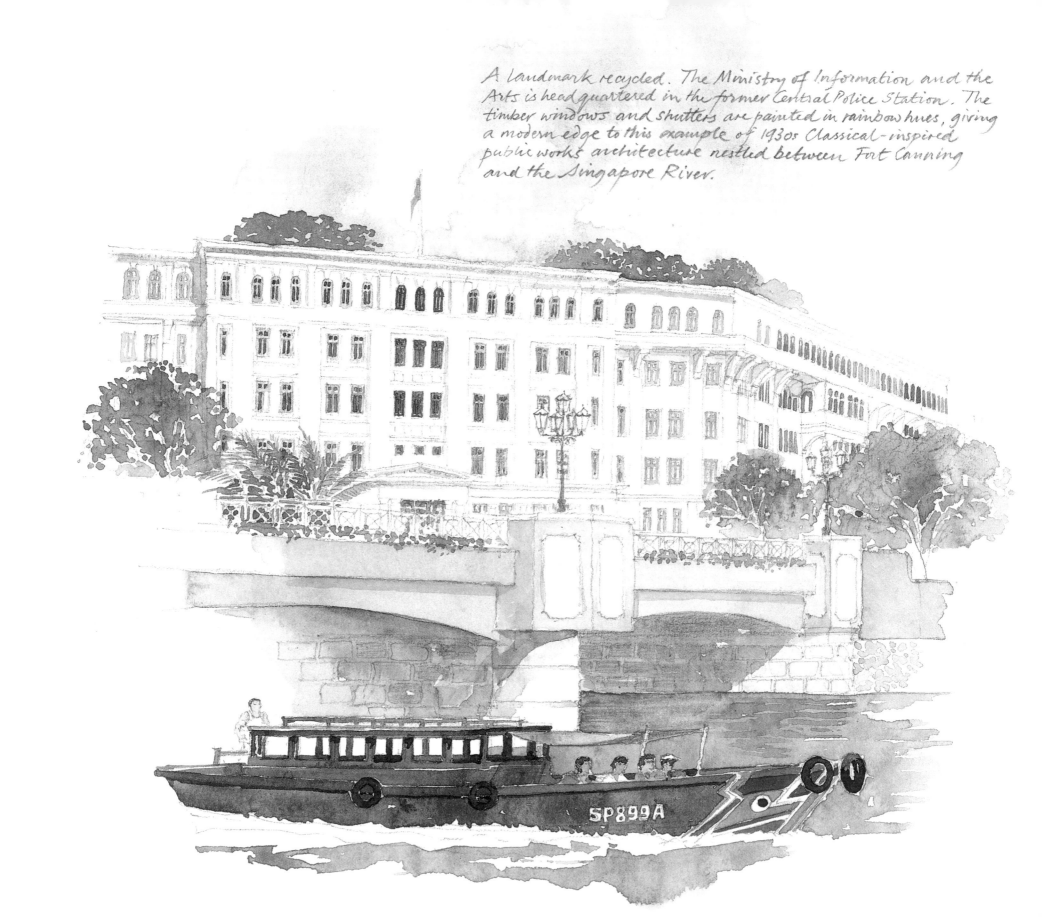

A landmark recycled. The Ministry of Information and the Arts is headquartered in the former Central Police Station. The timber windows and shutters are painted in rainbow hues, giving a modern edge to this example of 1930s Classical-inspired public works architecture nestled between Fort Canning and the Singapore River.

SP899A

Ornamental plasterwork so characteristic of Singapore's shophouse architecture.

ing the housing shortage by charging exorbitant rents, a Rent Control Ordinance was passed in 1947 which, in effect, froze rents. This had the adverse effect of making improvements to tenanted pre-war properties economically unattractive to owners.

INDEPENDENCE

In 1959, the colonial era finally ended. The People's Action Party came to power and the youthful Prime Minister Lee Kuan Yew assumed he would lead the newly independent island's population of 1.6 million to prosper in union with Malaya. But on 9 August 1965, Singapore found it had to pursue its destiny on its own.

Singapore's strategy for survival and development was essentially to take advantage of the favourable factors in the world economy and its own strategic location through sound policies and firm direction. In terms of housing and urban planning, the success of this approach can be vividly seen in the achievements of the Housing and Development Board (HDB) and the Urban Redevelopment Authority (URA). In 1960, the HDB was formed to tackle the housing problem. Its first five-year plan saw 51,000 units completed and soon the Board was well on its way to achieving the goal of providing homes for all Singaporeans.

To expedite central area redevelopment, the URA was empowered to acquire land. Smaller plots were amalgamated into larger parcels that were sold by tender to the highest bidder and redeveloped into modern skyscrapers. Yet there was already a strong conviction that central area renewal would need to be balanced with conservation of historic buildings. Great care was taken in deciding which buildings were to be demolished.

Singapore entered the 1970s as a politically stable state with a high rate of economic growth. Once again, progress was rapidly reflected in a multitude of new buildings and infrastructure projects, from the impressive new skyline of downtown skyscrapers to enormous land reclamation projects. Amidst such developments, the Preservation of Monuments Board was quietly set up in 1972. Priority was initially given to religious buildings and institutions built by or associated with the early pioneers. By 2001, 44 monuments had been gazetted.

In 1987, the Conservation Master Plan was unveiled. The plan nominated for preservation and conservation several large areas and more than 3,000 buildings of historical and architectural significance "to safeguard them for future Singaporeans". The Rent Control Act was dismantled and that, along with the gazetting of areas and buildings, gave many owners the confidence to invest in restoring their properties. Since then the URA has continued its work, guiding the passing of new legislation, developing a systematic and comprehensive approach and even bestowing annual architectural heritage awards.

Any great city must seek a balance between the old and the new, between heritage and progress. A stroll through almost any part of Singapore today will take you past a host of new construction as well as busy 19th century temples, mosques and churches, enchanting rows of pastel-painted shophouses, a variety of dignified civic and commercial structures — all living reminders of the island's wonderful diversity and unique history.

Civic Spirit

The old stones of empire are at home in the modern metropolis. Here, ranked closely around the Padang, the open green that once flanked the seafront but is now landlocked by a kilometre or more, are Singapore's most important civic structures. The oldest is the former Parliament House. It was built as a private residence in 1827, served various government offices and was remodelled in the 1950s in preparation for Singapore's independence. It served as Parliament House until 1999. The final flourishes to the ensemble include the Fullerton Building, built as the General Post Office in the twenties and now a luxury hotel, and the Supreme Court, completed on the eve of World War Two and still serving as the High Court.

It was only in the latter half of the 19th century that the pace of public building construction accelerated. The boom was triggered by the 1869 opening of the Suez Canal and the transfer of rule from India to London, and was sustained by the rubber and tin industries which brought new wealth to the port city. Styles ranged from Palladian to Gothic Revival, Victorian, Edwardian, neo-Renaissance and Neoclassical. The architects were mainly military engineers who joined the Public Works Department or its earlier equivalent.

The Civic Centre also embraces historic churches, schools now restored and adapted for new uses, and a handful of commercial buildings that have withstood development pressures. Commanding one end of the Padang is the Cricket Club. A stone's throw away from the other end is Raffles Hotel. Beautifully restored, it is once again airy, elegant and, to borrow a quote from a visitor in 1907 "one of the architectural ornaments of Singapore".

One of Singapore's oldest houses survived within convent walls for over a century and a half. Here the teaching-sisters marked their students' work and said their prayers. Known as Caldwell House, after the man who commissioned it in 1841, the building was restored together with the convent grounds and is now part of Chijmes.

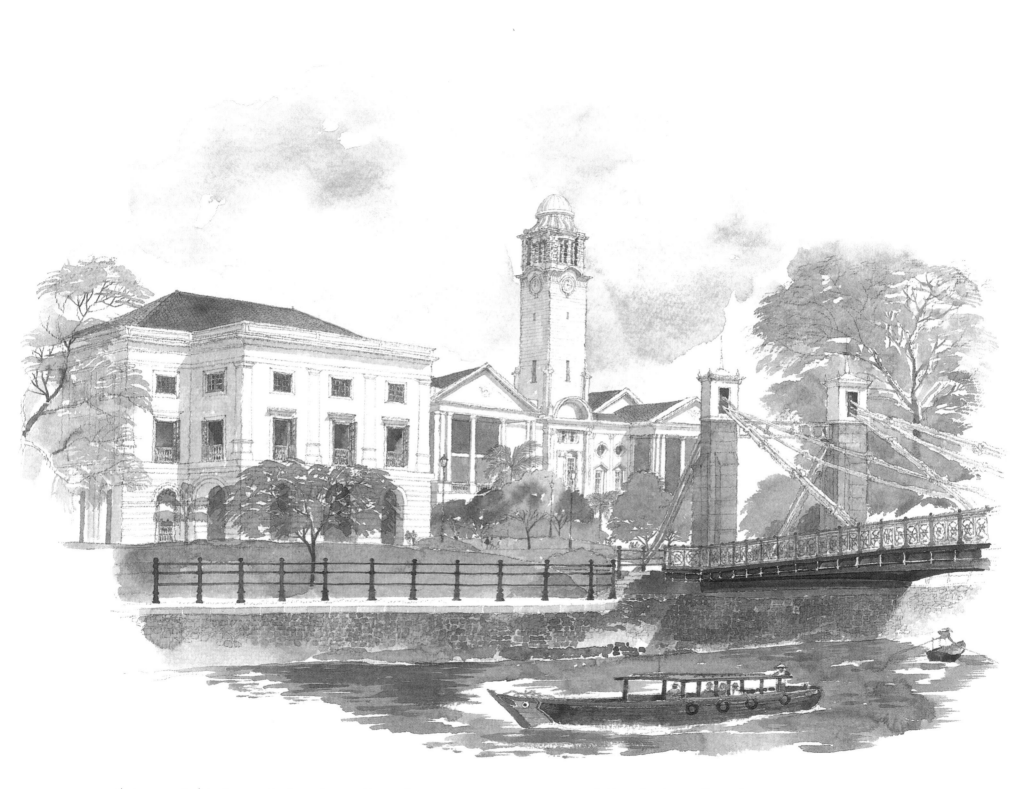

A trio of historic buildings that feature prominently in the city's cultural life are at the heart of the civic centre. The old Empress Place (left) is now the main building of the Asian Civilisations Museum. Beyond are the Victoria Theatre and Victoria Concert Hall which is the home of the Singapore Symphony Orchestra.

Survival story. The old Parliament House (below) was built in 1827 for a wealthy merchant who leased it to the government for offices. Re-modelled in the 1950s to serve as Parliament House to the newly independent Singapore, it now joins its neighbours as an arts venue.

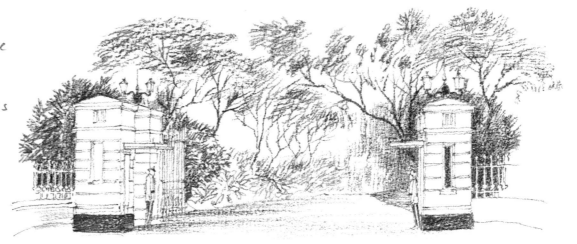

The Istana (right) is the official residence of the President of Singapore. Behind the handsome Orchard Road gates (above) are extensive grounds opened to the public on major holidays.

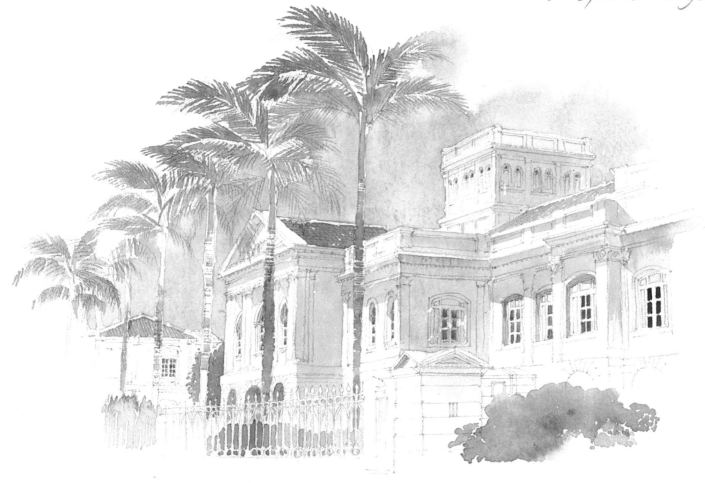

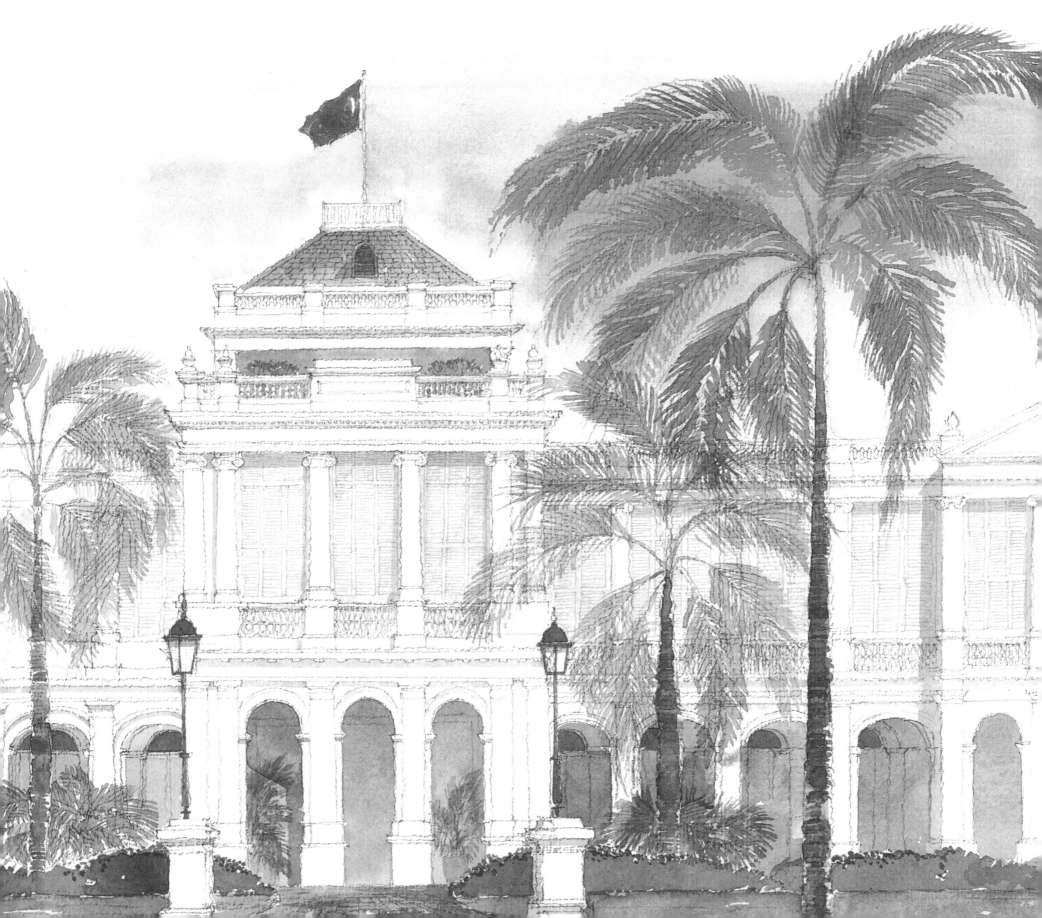

It is the National Heritage Board that looks after Singapore's three major museums. The Singapore Art Museum is housed in the original premises of St Joseph's Institution, a Catholic boys' school (below).

The old Tao Nan School (right) houses a part of the Asian Civilisations Museum. The National Museum (opposite page) opened in 1887 and is now dedicated to Singapore's history.

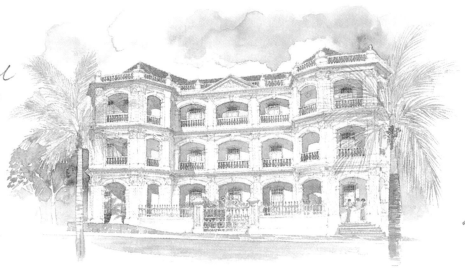

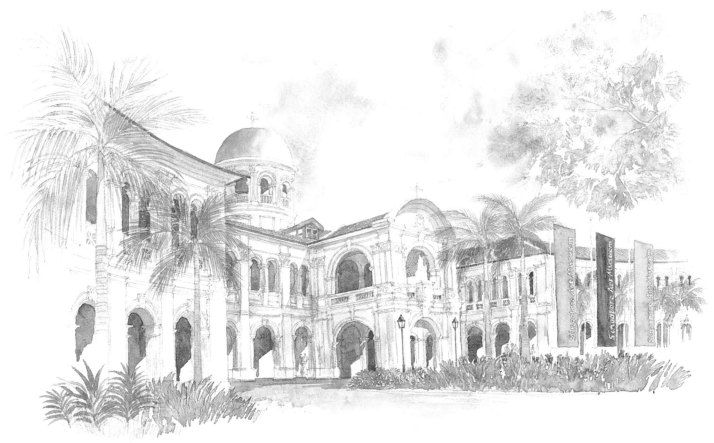

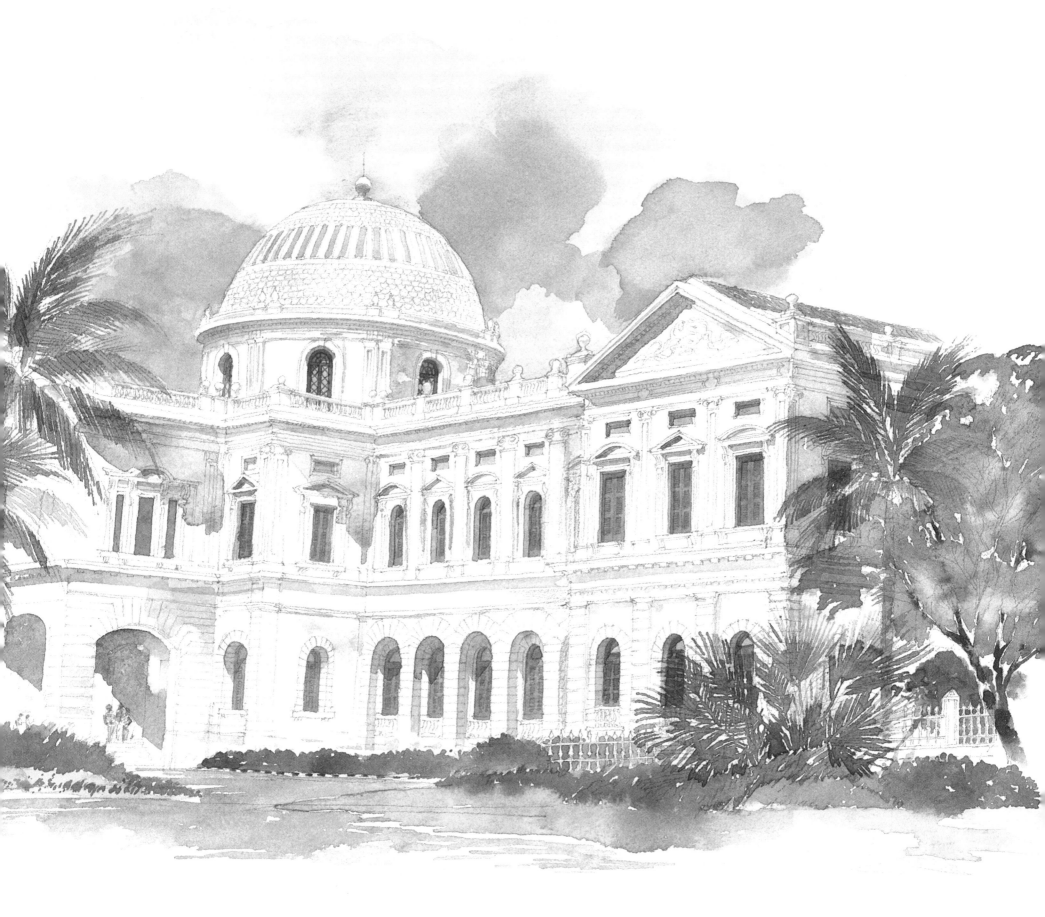

The British military bestowed the name Fort Canning when they took over the ancient hill once called Bukit Larangan, or Forbidden Hill, in 1857. The Fort Canning Country Club (below) was one of several military buildings constructed in the 1930s, just in time for the dramatic events leading up to the battle for Singapore in 1942. Fort Canning then served as Headquarters, Malay Command. The old gate (below right) harks back to an even earlier era when the first Christian cemetery claimed one of the slopes.

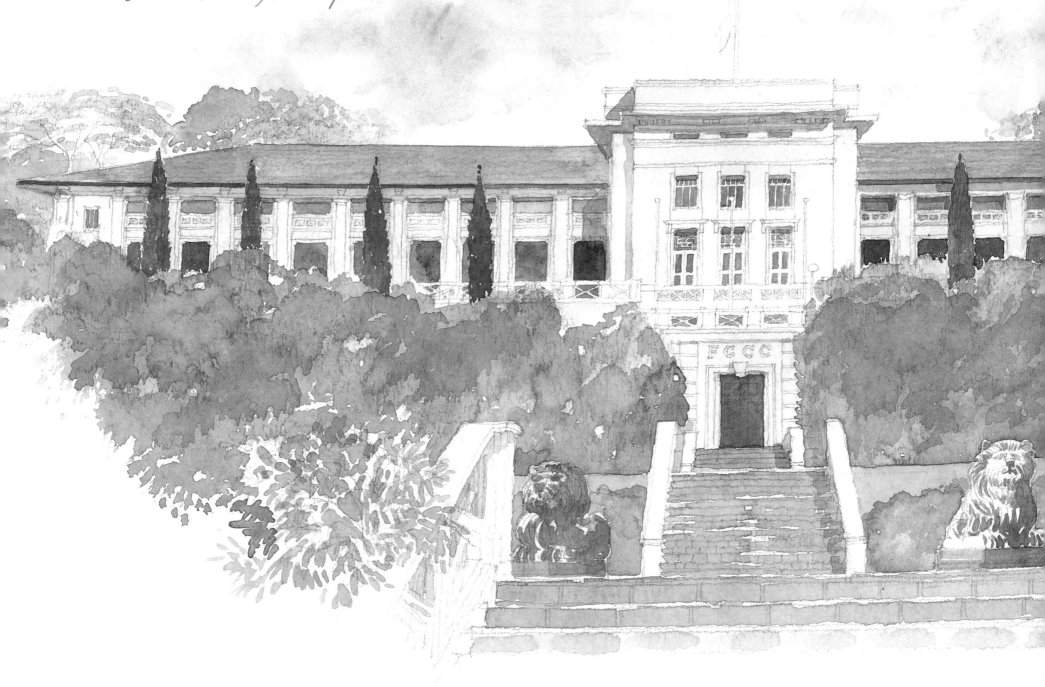

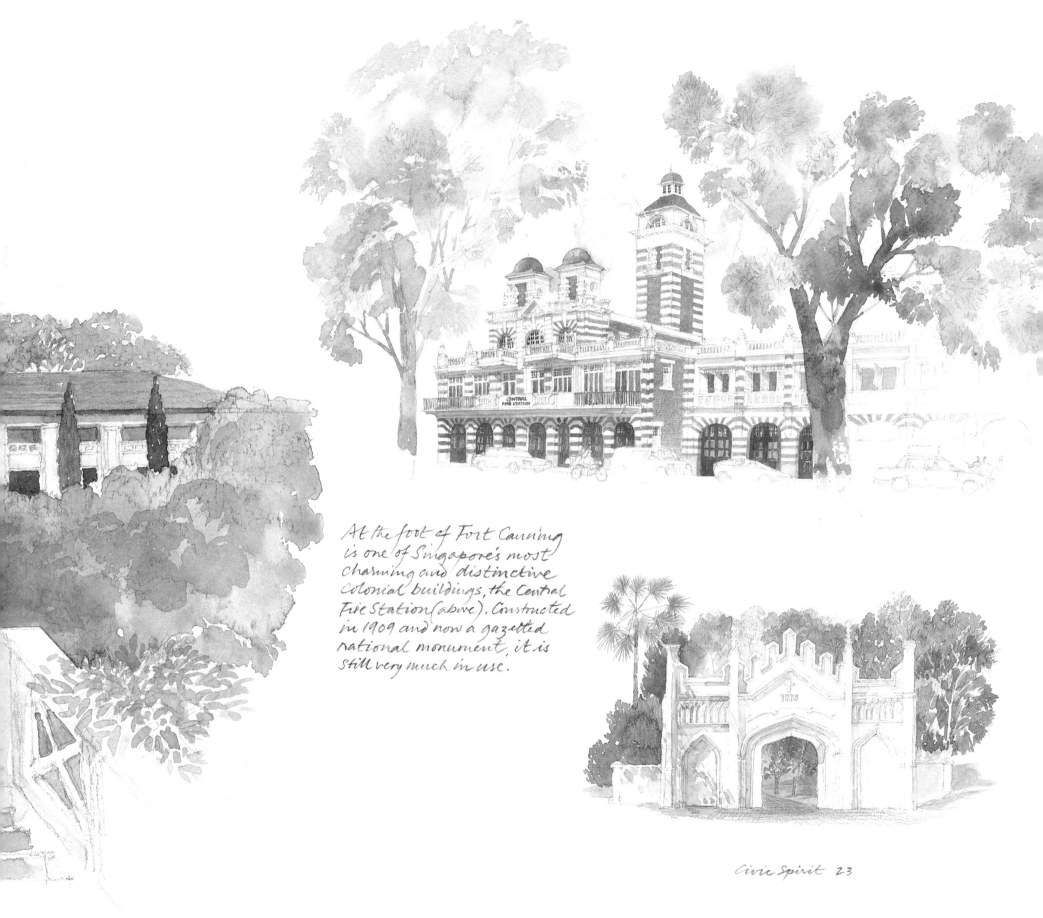

At the foot of Fort Canning
is one of Singapore's most
charming and distinctive
colonial buildings, the Central
Fire Station (above). Constructed
in 1909 and now a gazetted
national monument, it is
still very much in use.

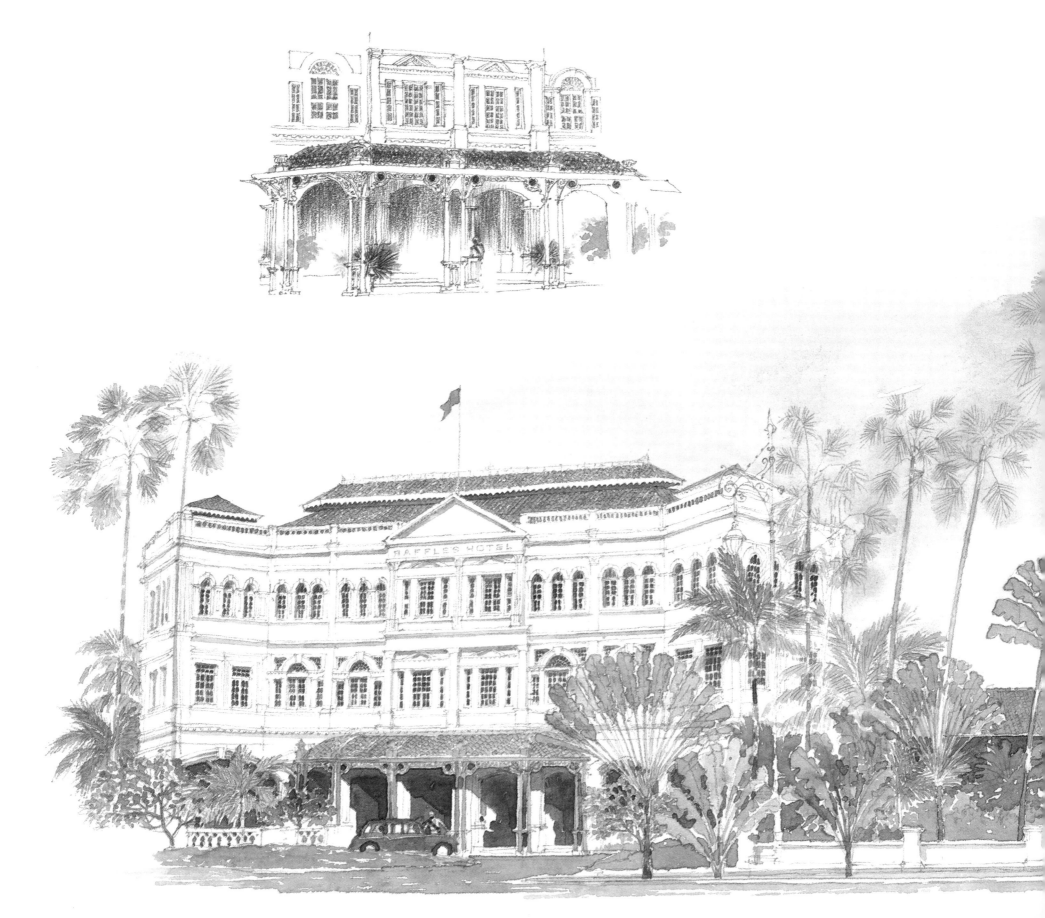

Grand historic hotel, international landmark and home of the Singapore Sling, Raffles Hotel opened to travellers in 1887. Having survived bankruptcy during the Great Depression and the Japanese Occupation during World War Two, it was closed from 1989 to 1991 for restoration. The cast iron portico was reinstated on the Main Building and the gardens extended and planted with new blooms. Old luggage labels - once found on the battered trunk of every seasoned traveller are displayed in the hotel's museum. The palm logo was inspired by the ubiquitous Traveller's Palm.

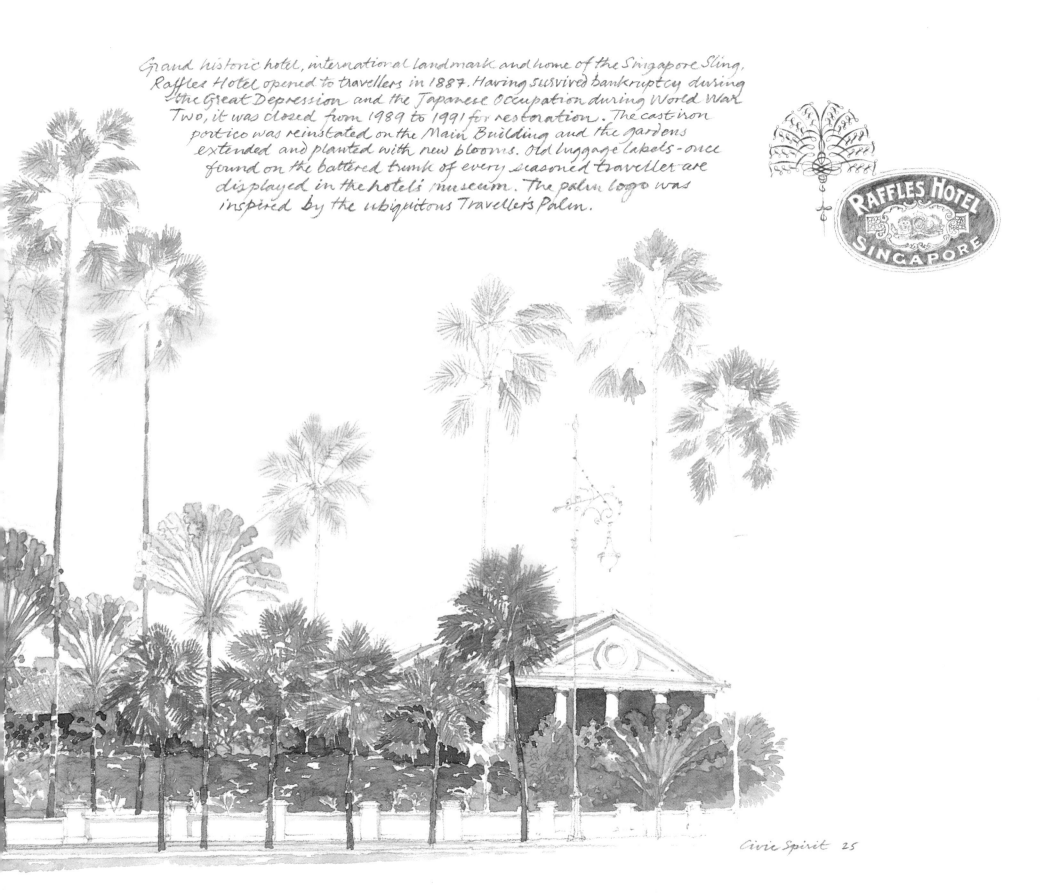

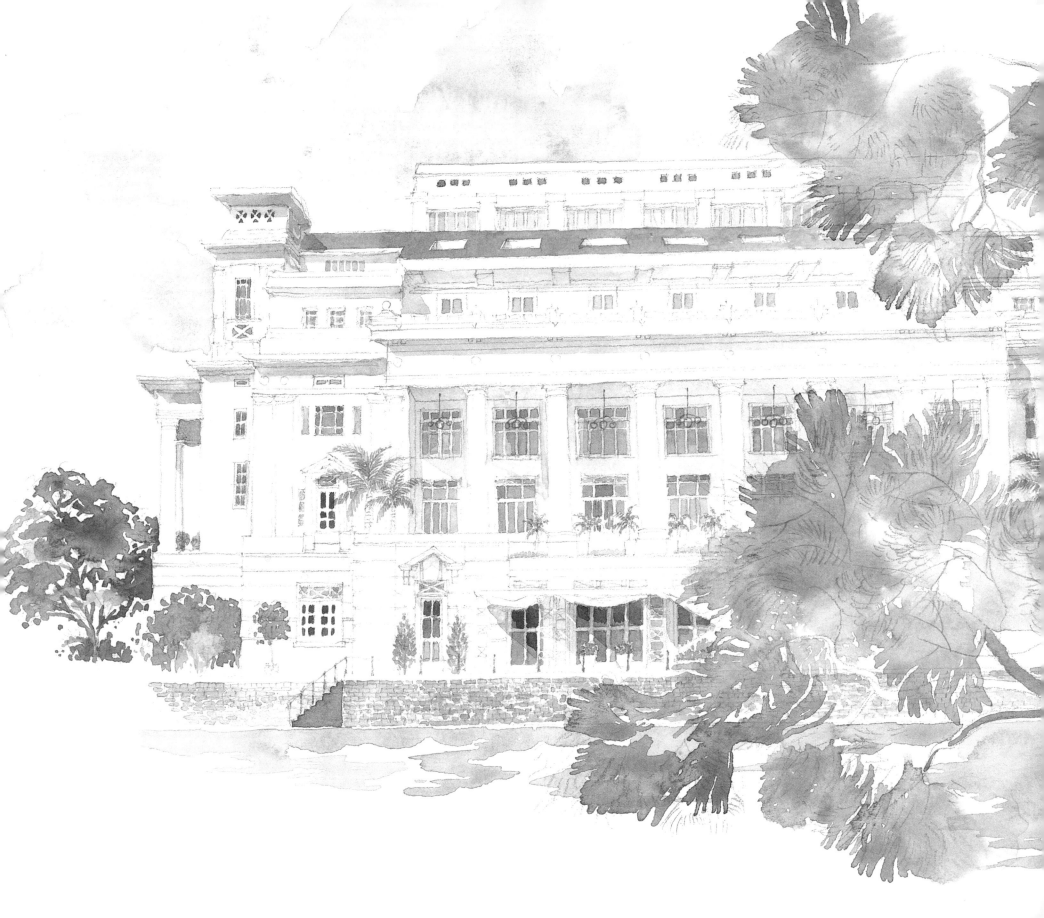

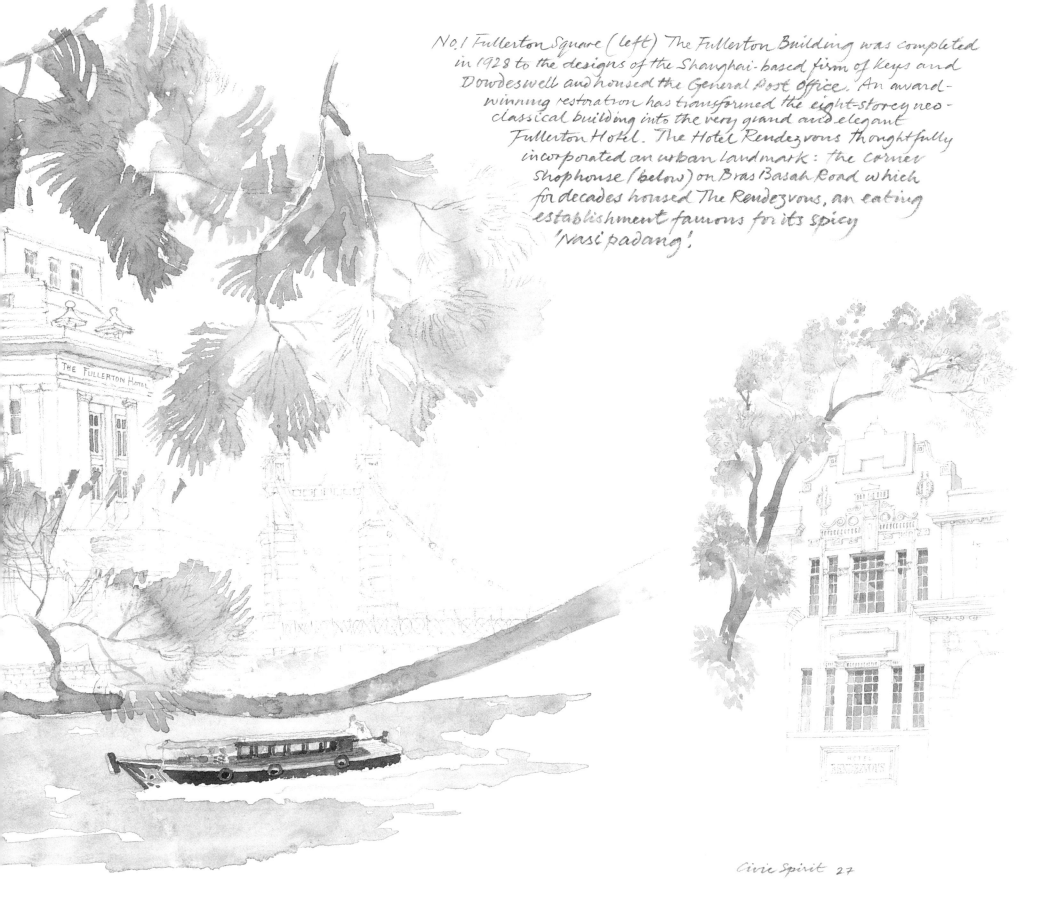

No.1 Fullerton Square (left) The Fullerton Building was completed in 1928 to the designs of the Shanghai-based firm of Keys and Dowdeswell and housed the General Post Office. An award-winning restoration has transformed the eight-storey neo-classical building into the very grand and elegant Fullerton Hotel. The Hotel Rendezvous thoughtfully incorporated an urban landmark: the corner shophouse (below) on Bras Basah Road which for decades housed The Rendezvous, an eating establishment famous for its spicy 'Nasi padang'.

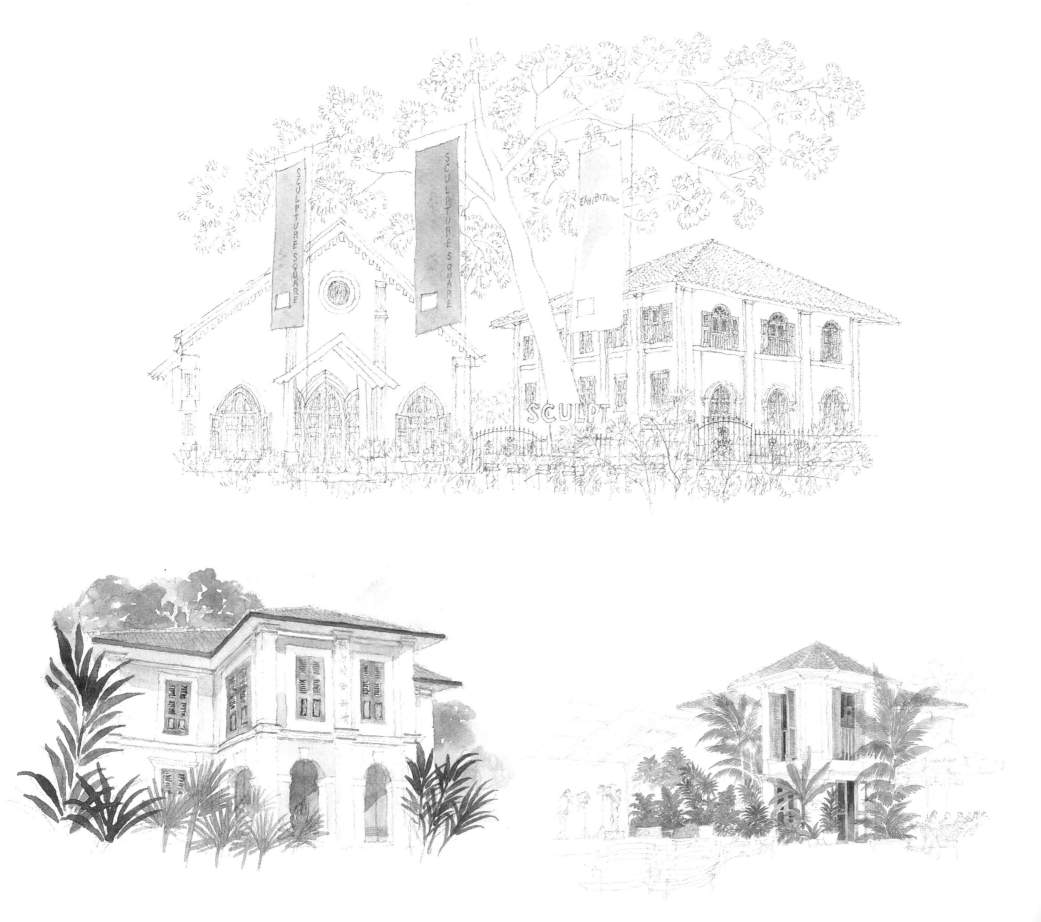

Art in the City. Not long ago Waterloo Street appeared dilapidated and abandoned. Today it is a lively scene of numerous exhibitions and performances. Several arts groups are happily housed in the recycled old buildings, the matchmaking of talent with space guided by the National Arts Council. Among the resident groups is The Young Musicians Society (right). Sculpture Square (left above) was once a church and parish house. The Chinese Calligraphy Centre and Action Theatre (left below) have made use of typical 19th century bungalows.

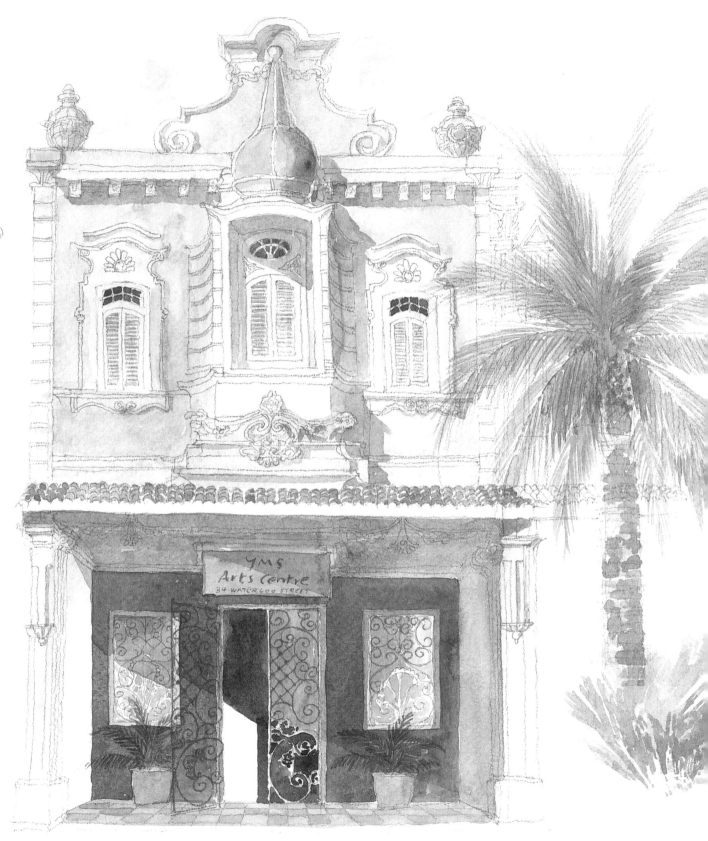

Opened in 1914 Stamford House was briefly an annex of Raffles Hotel called Grosvenor Hotel in the 1920s. After restoration it reopened as a shopping centre in 1995, with its handsome plasterwork, including the pediment, and cast-iron details all beautifully restored.

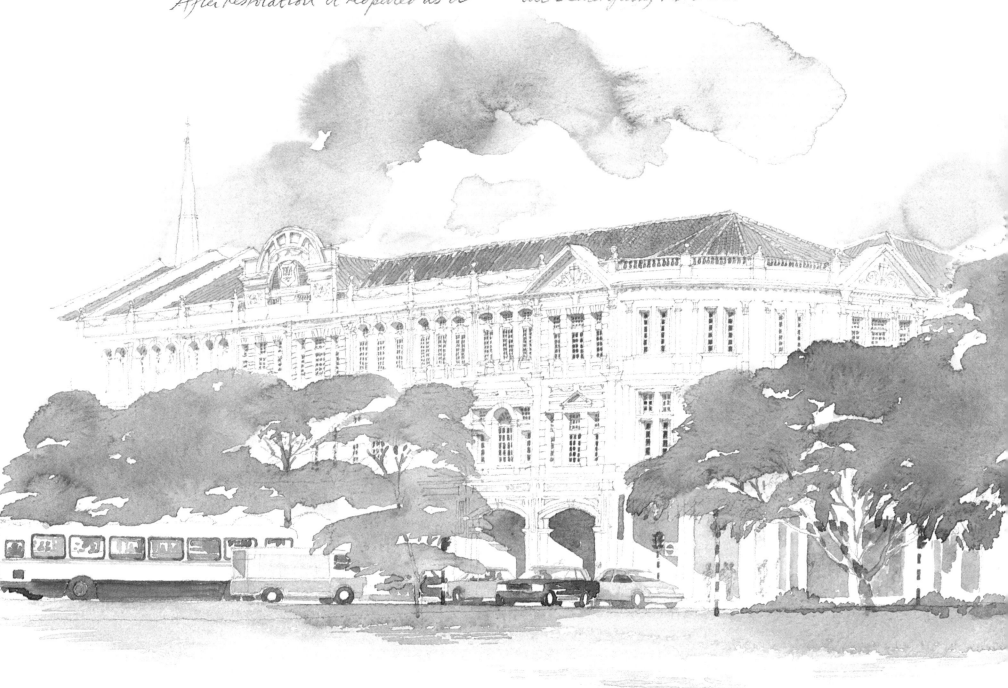

The MPH Building (below) houses a much-loved bookshop and has been a familiar sight along Stamford Road since 1908 when it opened as the headquarters of the Methodist Publishing House.

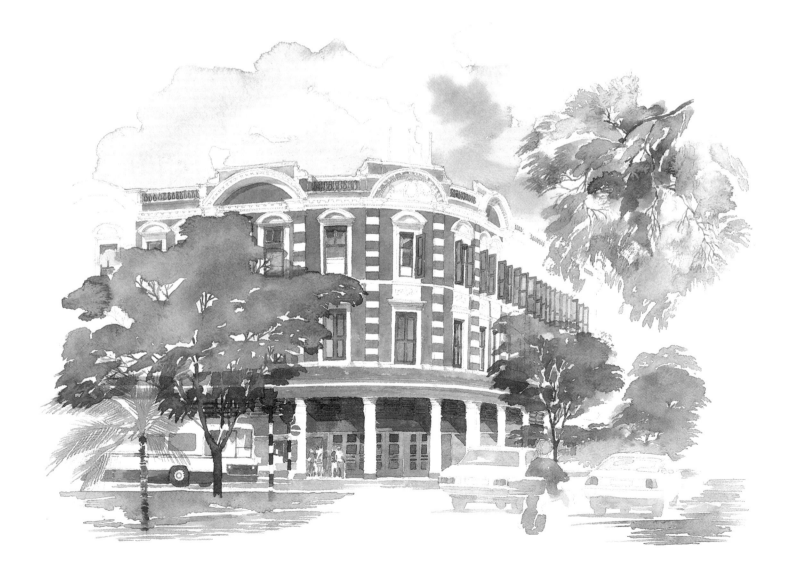

The River Revived

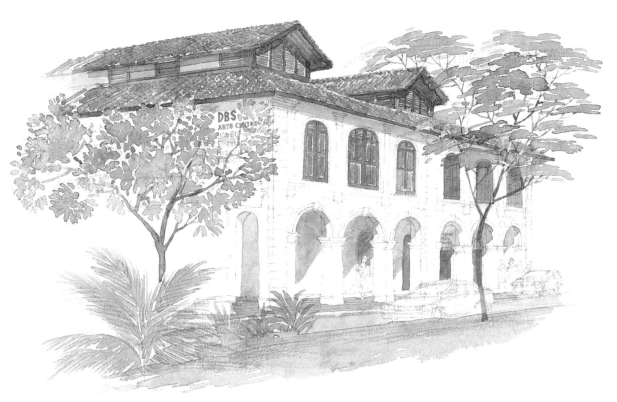

It was Singapore's free port status that set the pace for the river's early and rapid development. The curve of Boat Quay was created by banking up a swampy shore in the 1820s and was soon lined with the premises of wealthy European and Chinese merchants. Goods arriving by all manner of seafaring craft were ferried to the warehouses by small boats for storage and, eventually, reshipment to their final destination. Further upstream, at Clarke and Robertson quays, development was more varied and the warehouses were interspersed with factories, engineering works and Whampoa's famous Ice House.

Gradually, inevitably, the Singapore River ceased to play such an important role in the island's trade. By the early 1980s, progress had nudged out the river's entrepot trade completely. The bumboats that had for a century and a half jostled for space along the crowded quays were relocated to Pasir Panjang. A massive river clean-up project was launched but many of the dilapidated buildings faced an uncertain future.

The turning point came in 1989 when Boat Quay was gazetted a Conservation Area. Today the entire length of the river is lined with restored shophouses and godowns interspersed with new developments. Where once spices and rubber were stored are restaurants, nightclubs, hotels, galleries and even a theatre for live performances. Bumboats now serve as river taxis while the adjacent areas, including Mohamed Sultan Road, are enjoying a new lease of life. Singapore's pioneering merchants would undoubtedly approve the entrepreneurial spirit that has brought life back to the river.

The Singapore Repertory Theatre inhabits an old warehouse in Robertson Quay. The generosity of DBS Bank in supporting the company and conversion is recognised in the naming of the building as the DBS Arts Centre.

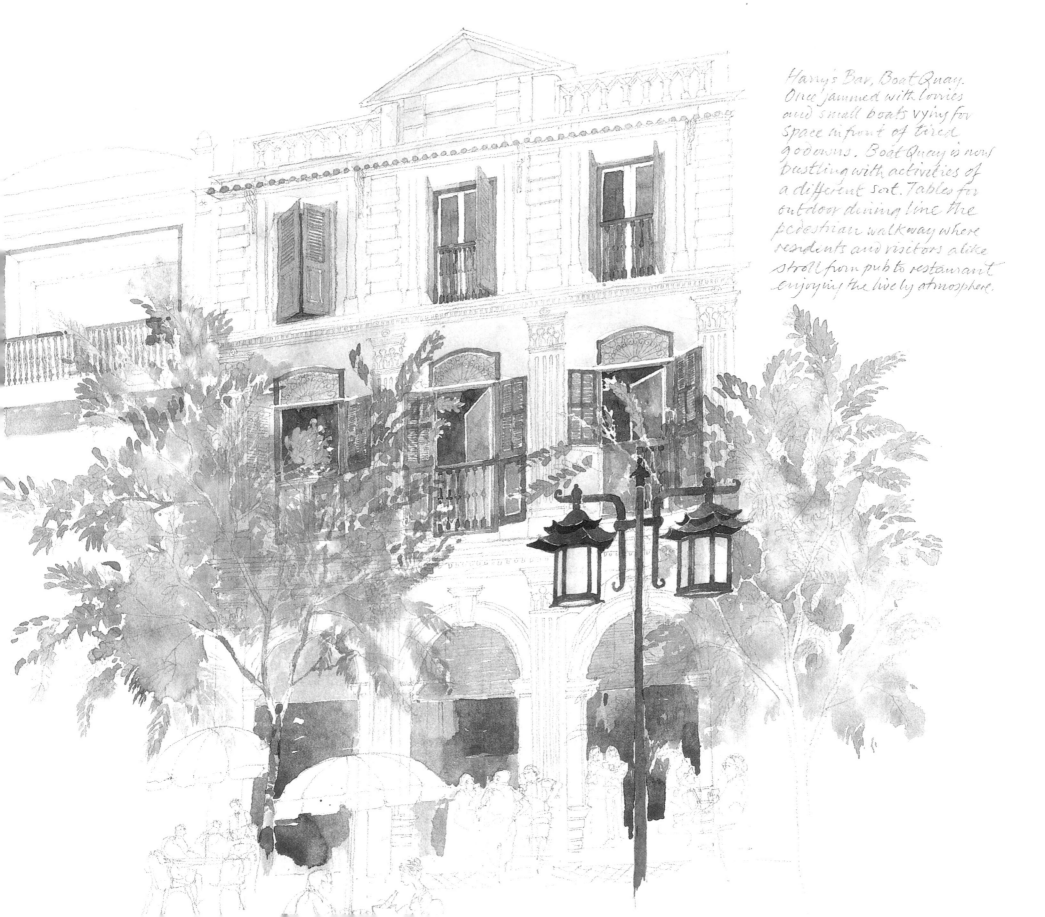

Harry's Bar, Boat Quay. Once jammed with lorries and small boats vying for space in front of tired godowns. Boat Quay is now bustling with activities of a different sort. Tables for outdoor dining line the pedestrian walkway where residents and visitors alike stroll from pub to restaurant enjoying the lively atmosphere.

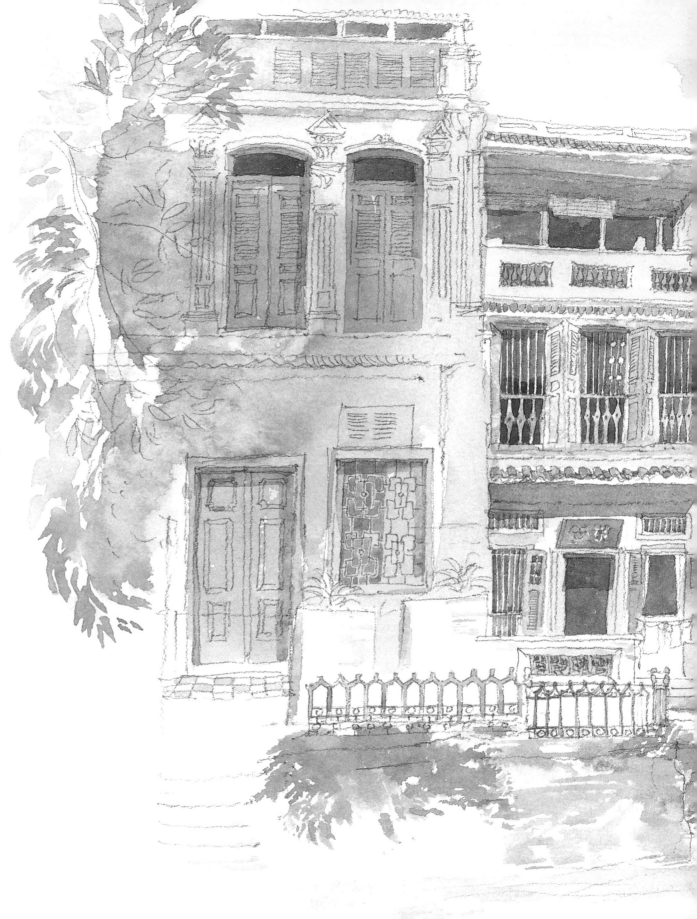

Old meets new head on at Mohamed Sultan Road. The early 19th century terrace houses not far from the Singapore River were commissioned by prosperous Chinese traders and are special because of the elaborateness of the Chinese handcrafted details, ranging from geometric panels and painted scrolls to carved timber screens. Today the former residences house restaurants, trendy clubs and pubs.

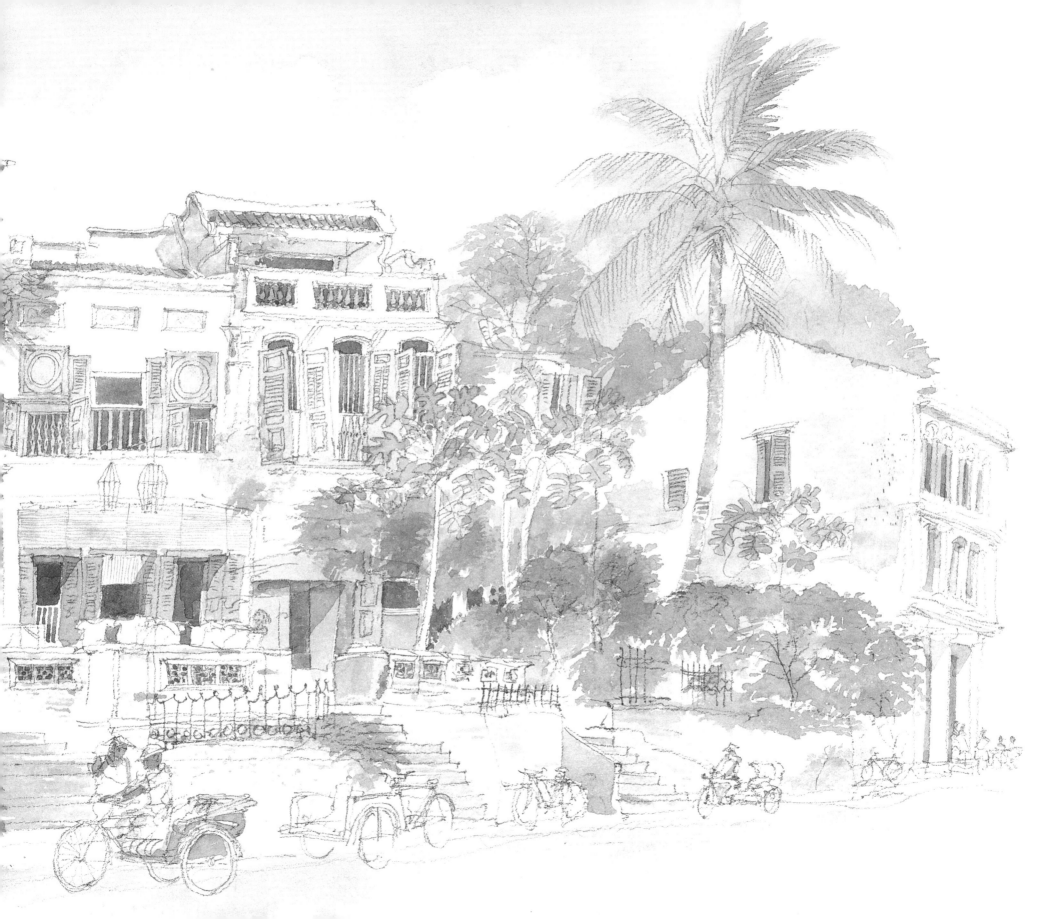

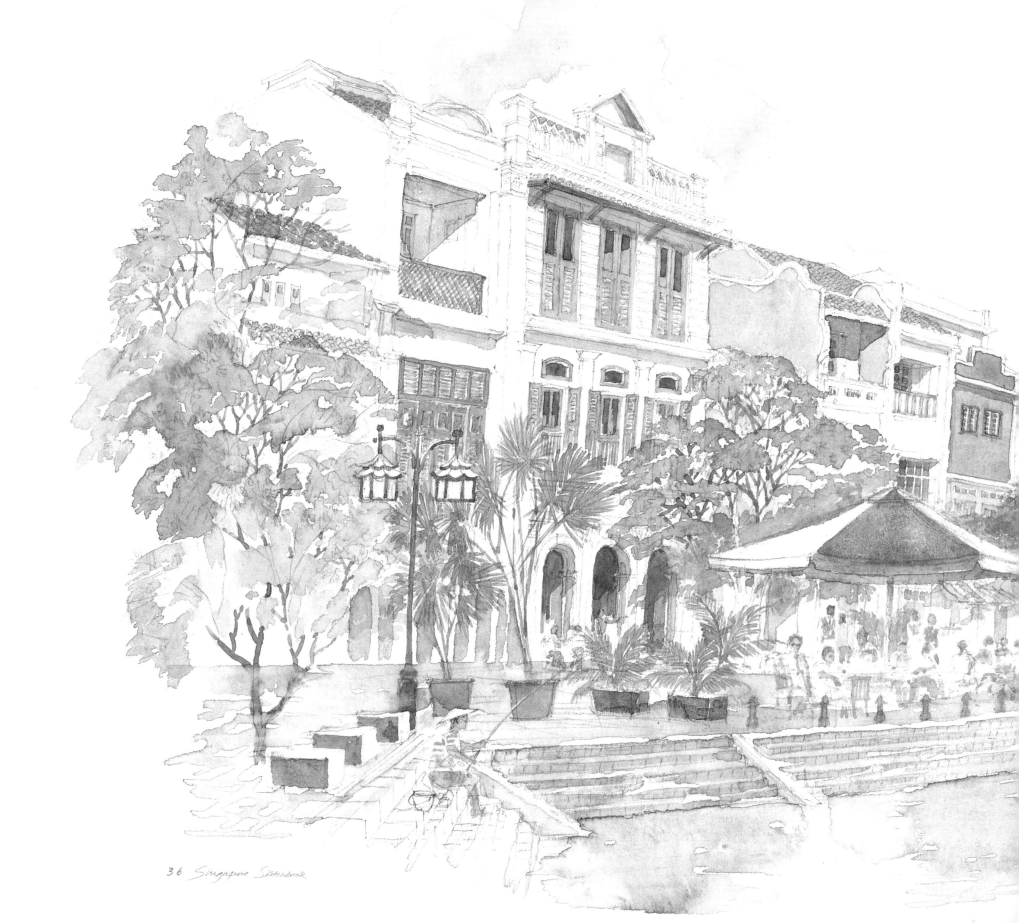

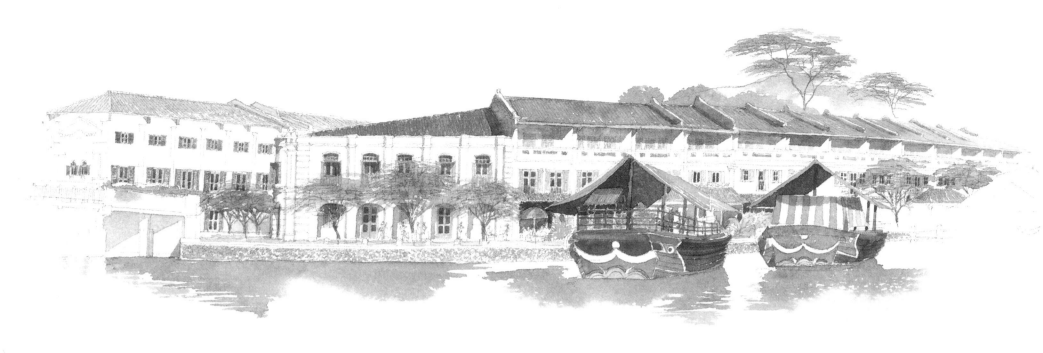

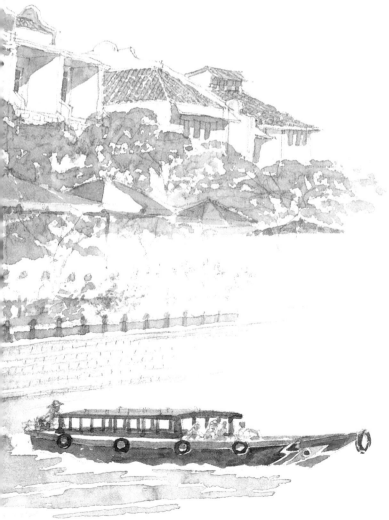

The curve of Boat Quay (left) has been a familiar sight for generations of Singaporeans. With the old buildings renewed and thriving in the modern city, the scene serves as a potent reminder of Singapore's early mercantile roots. Further up river at Clarke Quay (above) coolie labourers once broke their backs or made fantastic fortunes. Progress nudged the warehouses and godowns to other locations but the humble historic buildings were brought back to life as a festival village.

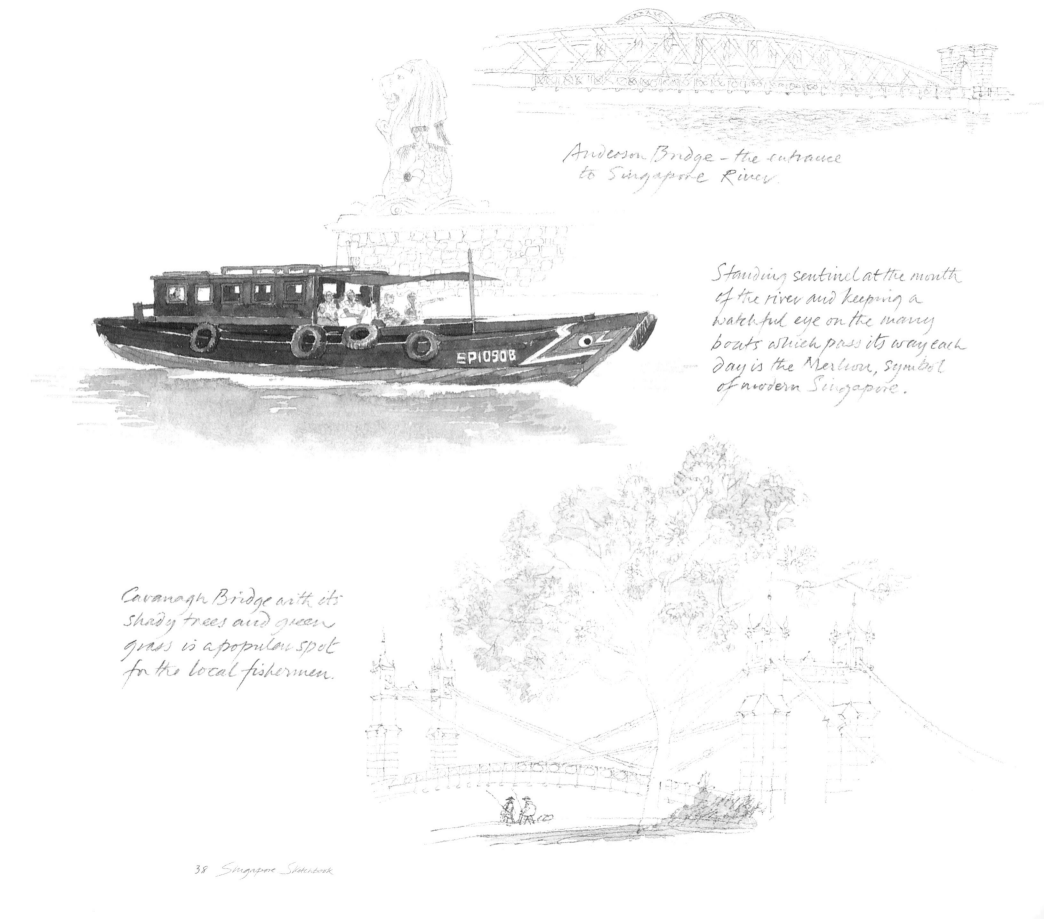

Anderson Bridge — the entrance
to Singapore River.

Standing sentinel at the mouth
of the river and keeping a
watchful eye on the many
boats which pass its way each
day is the Merlion, symbol
of modern Singapore.

Cavanagh Bridge with its
shady trees and green
grass is a popular spot
for the local fishermen.

The bumboats are back!
With many more landing points,
increased river taxi service and
special cruises in traditional
bumboats, it is once again easy
to travel by river.

There has been a bridge over
the river in this location
since 1822 but these
decorative lamp posts were
installed when Coleman
Bridge was rebuilt in 1989.

The oldest bridge across the river
is today for pedestrians only. The
cast-iron structure imported from
Glasgow remains an important
link between Raffles Place and
the Civic District.

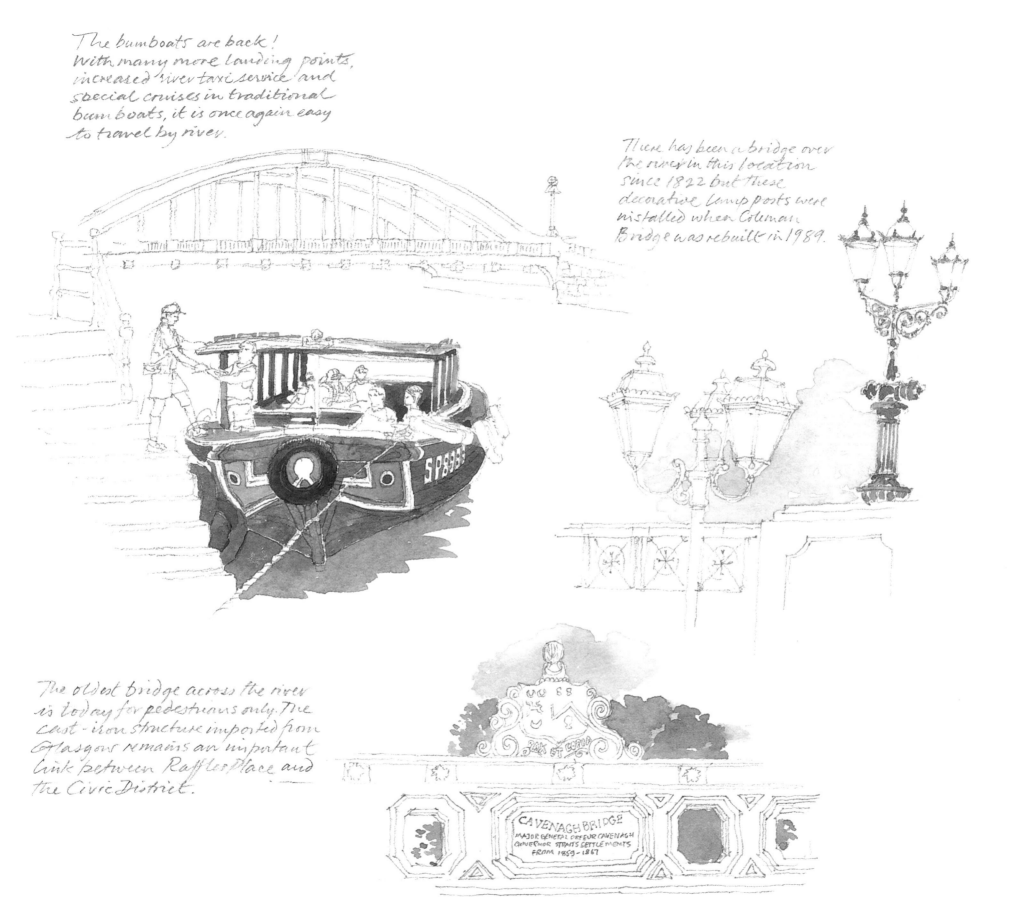

SP8838

CAVENAGH BRIDGE
MAJOR GENERAL ORFEUR CAVENAGH
GOVERNOR STRAITS SETTLEMENTS
FROM 1859-1867

Soul of the City

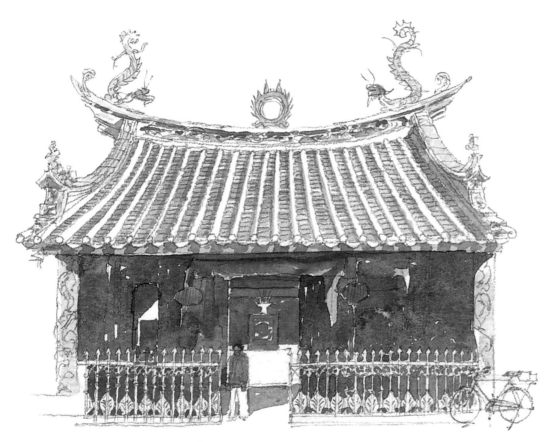

Thian Hock Keng may no longer hug the seashore, but thanks to a recent restoration, it is much the same as it was when wealthy Hokkien merchants gathered in the early 1840s to celebrate its completion. The restoration yielded several wonderful discoveries including a scroll inscribed by the imperial edict of Emperor Guang Xu of the Qing Dynasty.

To Singaporeans, Chinatown, Kampong Glam and Little India are more than mere bricks and mortar. These three historic districts evoke powerful memories of immigrant ancestors. The city is defined as much by the fabric of their narrow streets as by the dramatic skyscrapers that tower over them.

Chinatown, the largest of the three, was created by Sir Stamford Raffles and his advisers. Anticipating that the Chinese would eventually form the largest segment of the population, they allocated the entire area south of the Singapore River beyond Boat Quay and Commercial Square to the Chinese in the 1823 Town Plan. Eventually four distinct districts evolved: Telok Ayer, Kreta Ayer, Bukit Pasoh and Tanjong Pagar.

Kampong Glam was originally a fishing village at the mouth of the Rochor River. It took its name from the Gelam tree, which grew in abundance there and produced a bark for caulking boats. Raffles reserved the area for the Muslim community and over time it attracted settlers from the Middle East and South-east Asia. Their origins are reflected in some of the street names – Arab Street, Baghdad Street, Pahang Street.

Unlike the other two districts, where British policies determined ethnic character, Little India evolved gradually. Initially the land was attractive to South Indians engaged in cattle-related activities due to the abundance of water and grass. For many years the bungalows of Europeans and Eurasian civil servants co-existed with cattle pens and slaughterhouses. Eventually the bungalows made way for shophouses. By the time cattle were banned in 1936, Little India was much as we know it today.

Club Street. This area of Chinatown contains a lively mixture of
shophouse styles all unified by the ubiquitous five-foot way. Once a
popular location for Chinese clan associations, it is now bubbling with
advertising and architectural firms, art galleries, small hotels and
lots of great restaurants.

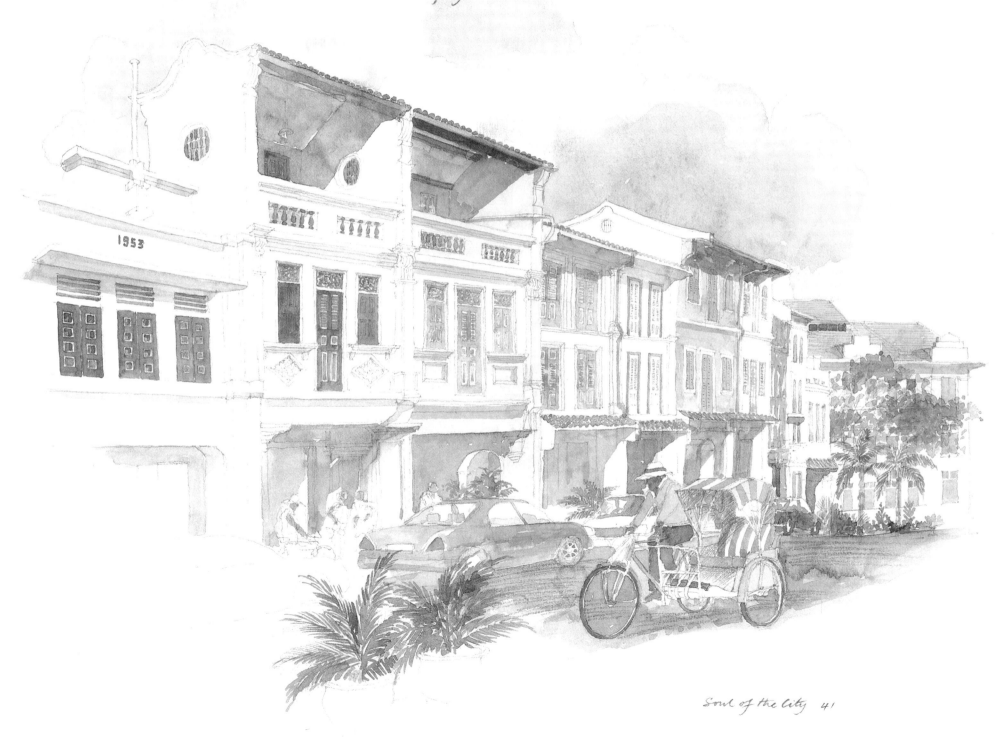

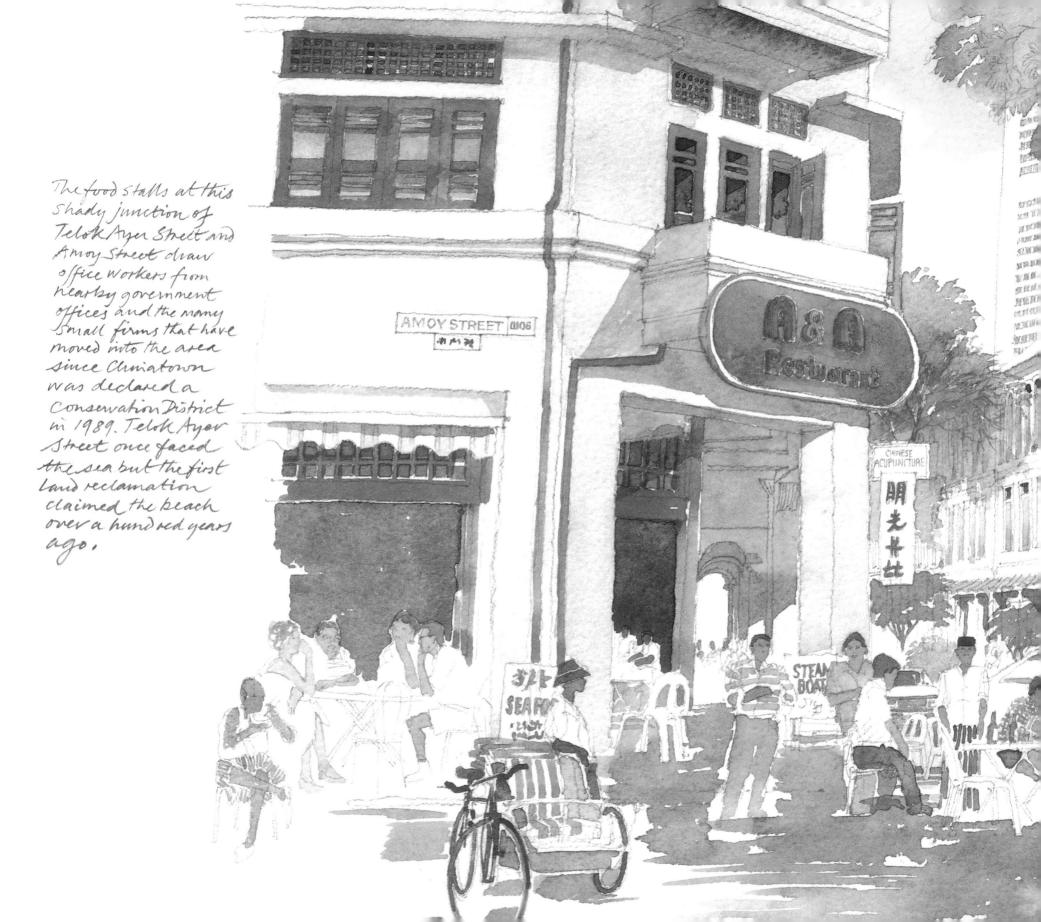

The food stalls at this
shady junction of
Telok Ayer Street and
Amoy Street draw
office workers from
nearby government
offices and the many
small firms that have
moved into the area
since Chinatown
was declared a
Conservation District
in 1989. Telok Ayer
Street once faced
the sea but the first
land reclamation
claimed the beach
over a hundred years
ago.

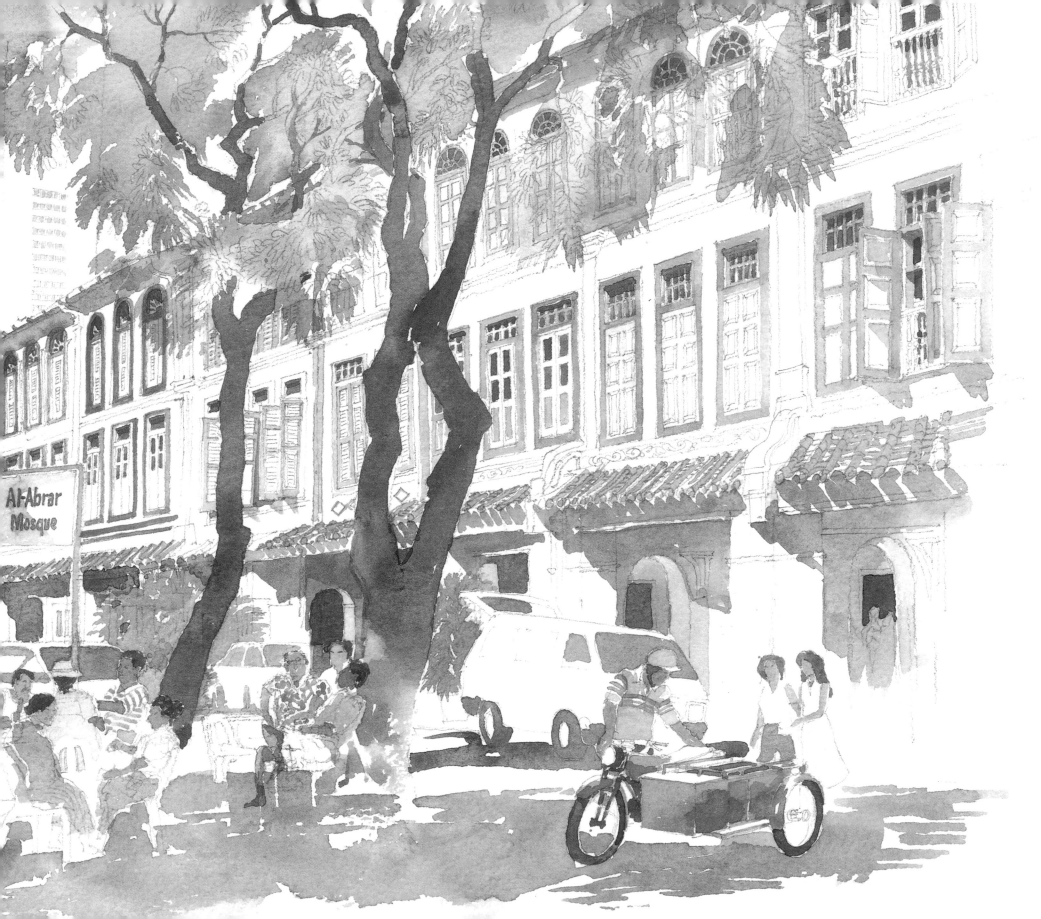

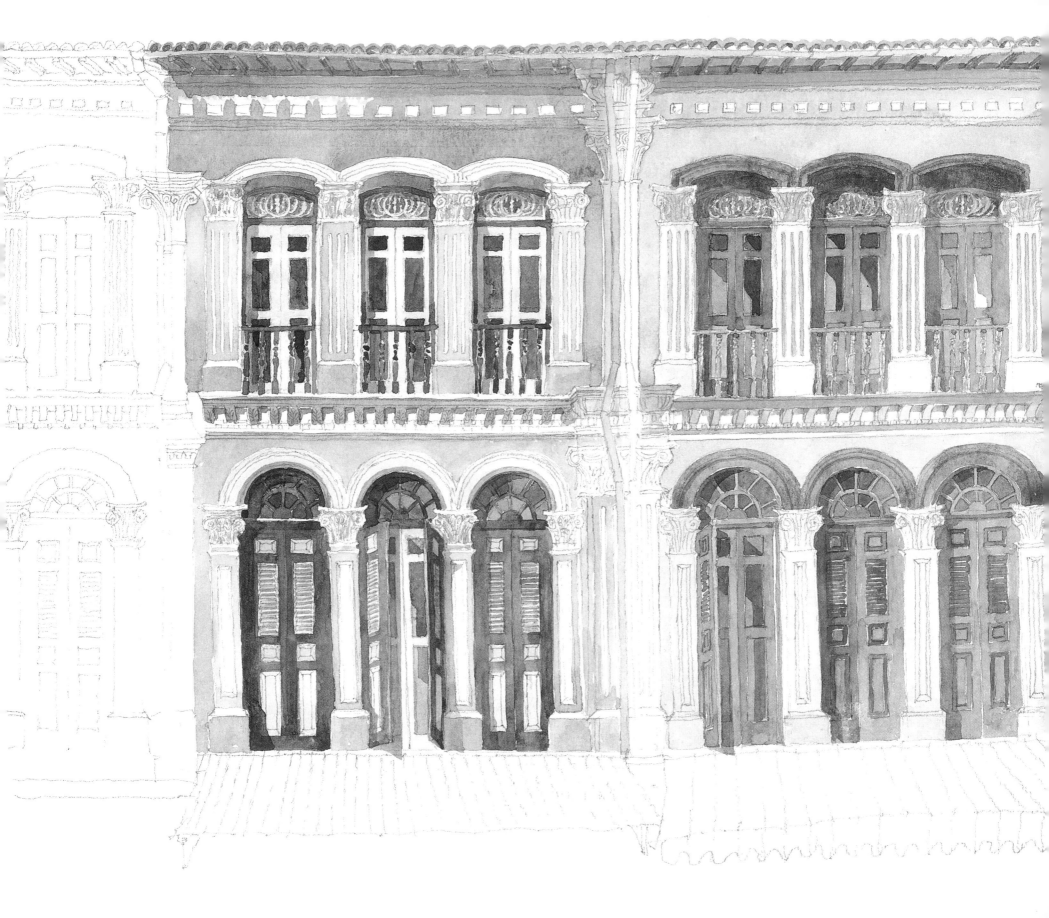

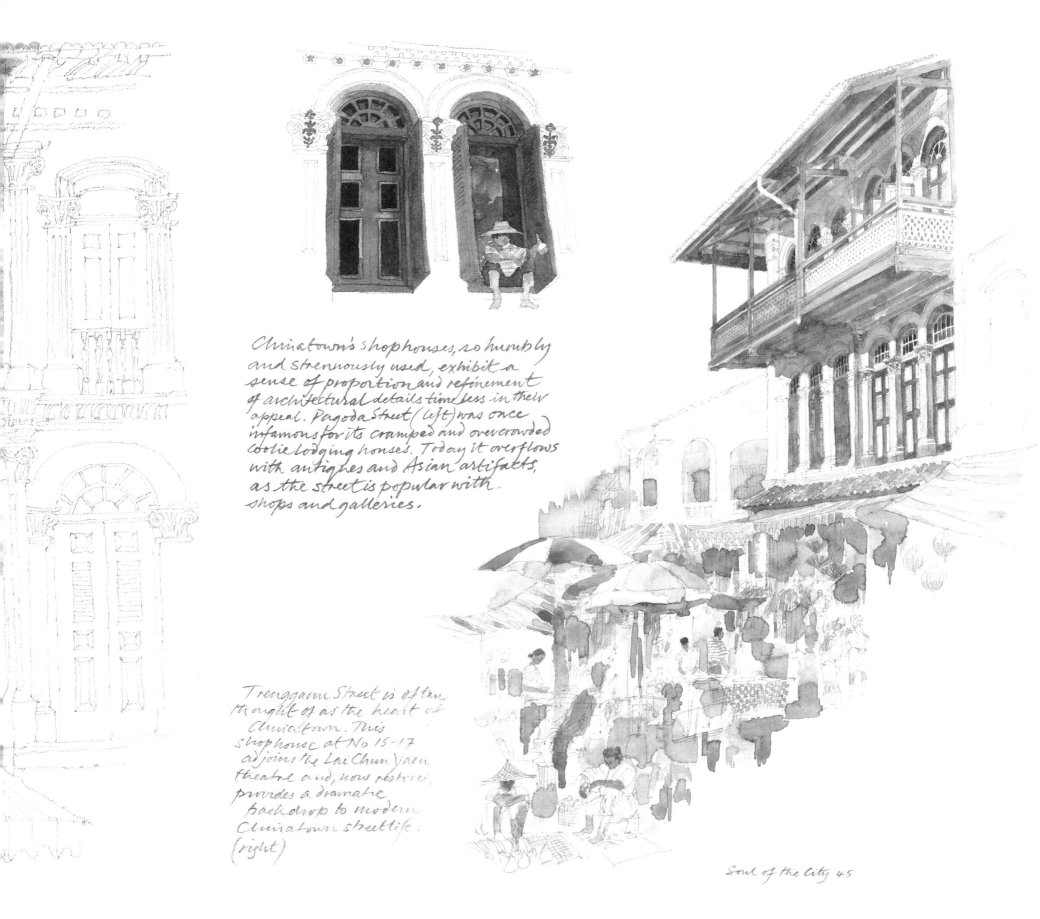

Chinatown's shophouses, so humbly
and strenuously used, exhibit a
sense of proportion and refinement
of architectural details timeless in their
appeal. Pagoda Street (left) was once
infamous for its cramped and overcrowded
coolie lodging houses. Today it overflows
with antiques and Asian artifacts,
as the street is popular with
shops and galleries.

Trengganu Street is often
thought of as the heart of
Chinatown. This
shophouse at No 15-17
adjoins the Lai Chun Yuen
theatre and, now restored,
provides a dramatic
backdrop to modern
Chinatown streetlife.
(right)

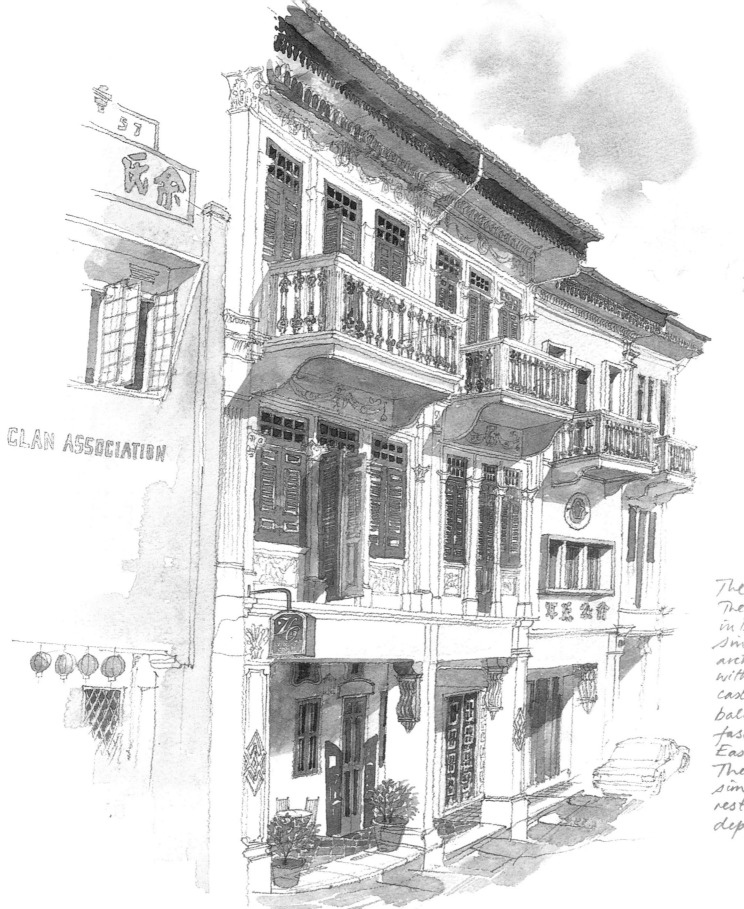

CLAN ASSOCIATION

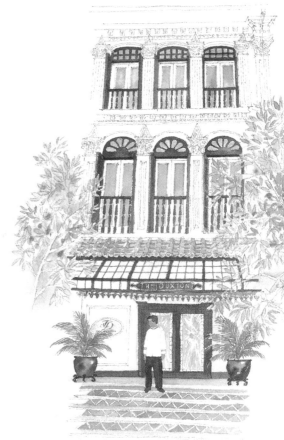

The many moods of Chinatown. The grouping of 1930s shophouses in Bukit Pasoh (left) exhibits Singapore's pre-war shophouse architecture at its most flamboyant with elegant plasterwork, lacey cast-iron balustrades, cantilevered balconies and carved timbered fascia boards. The old Great Eastern Hotel and the Majestic Theatre (right above) are of a similar vintage but more restrained. The hotel is now a department store.

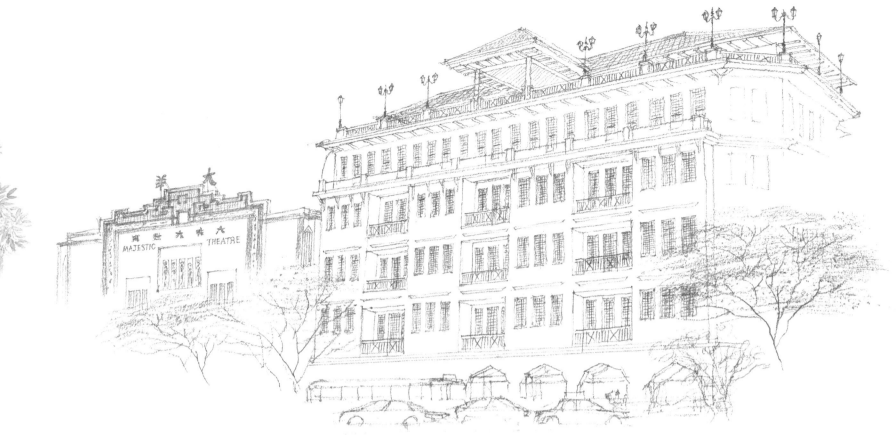

Little gems. The Duxton Hotel (above left) was created from eight shophouses along Duxton Road. The corner shophouse (right) with elaborate windows at the corner of South Bridge Road and Ramah Street was built for the photographer Lee Yin Fan. The original building plan was dated 1900.

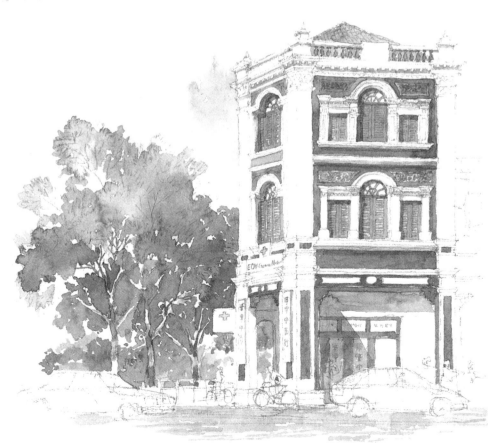

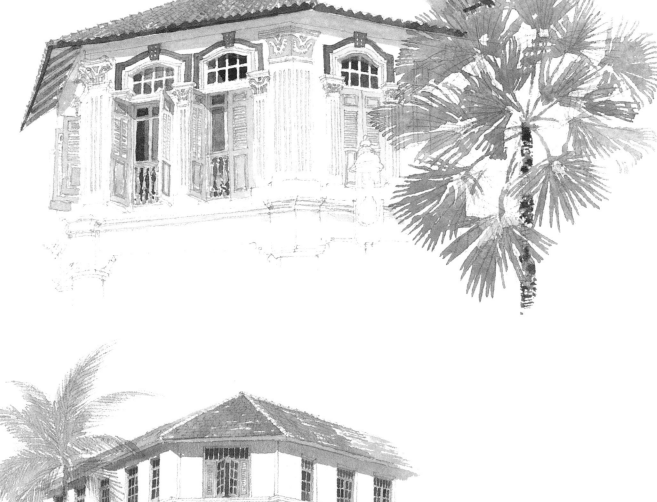

This shophouse sits at one corner of Bussorah Street.

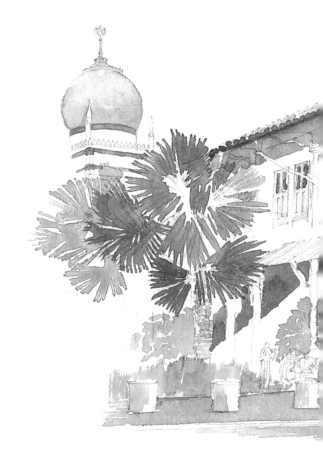

A more modern version of shophouse architecture at the corner of Sultan Gate and Beach Road. Beach Road once faced the beach but the first land reclamation was undertaken several decades before this building was constructed.

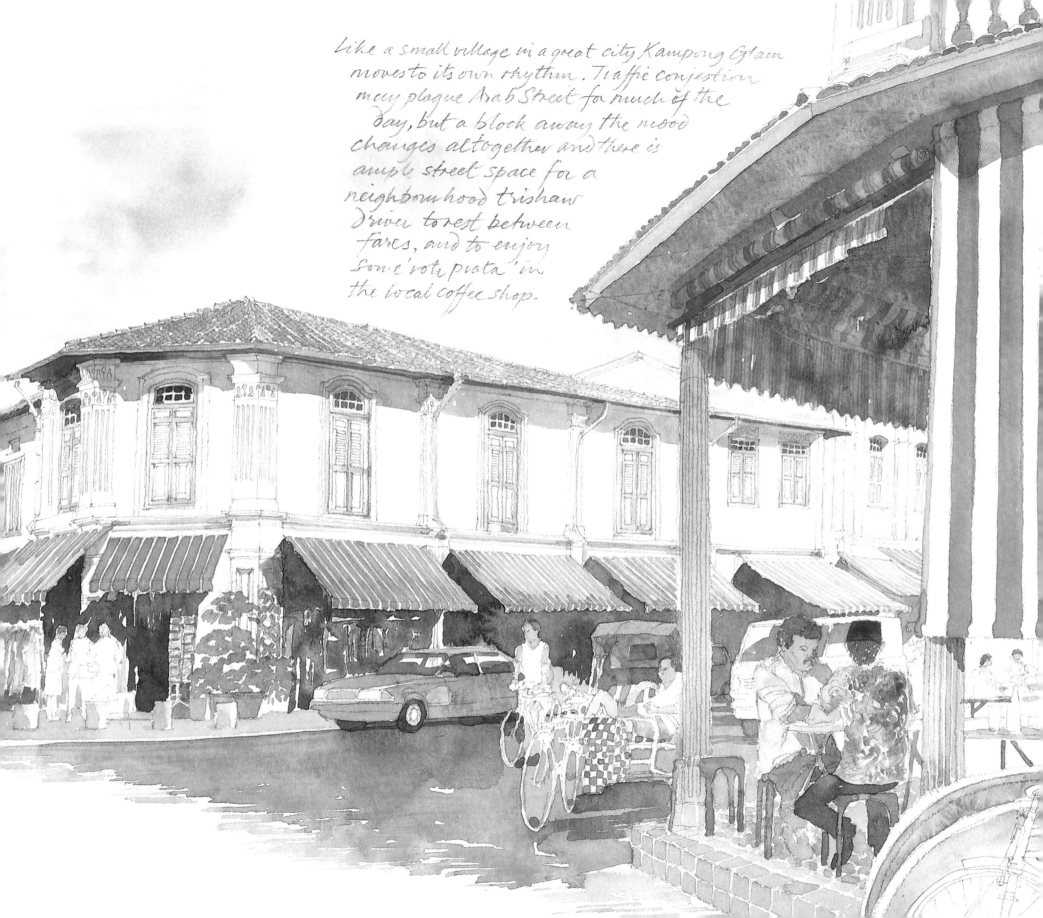

Like a small village in a great city Kampong Glam
moves to its own rhythm. Traffic congestion
may plague Arab Street for much of the
day, but a block away the mood
changes altogether and there is
ample street space for a
neighbourhood trishaw
driver to rest between
fares, and to enjoy
some 'roti prata' in
the local coffee shop.

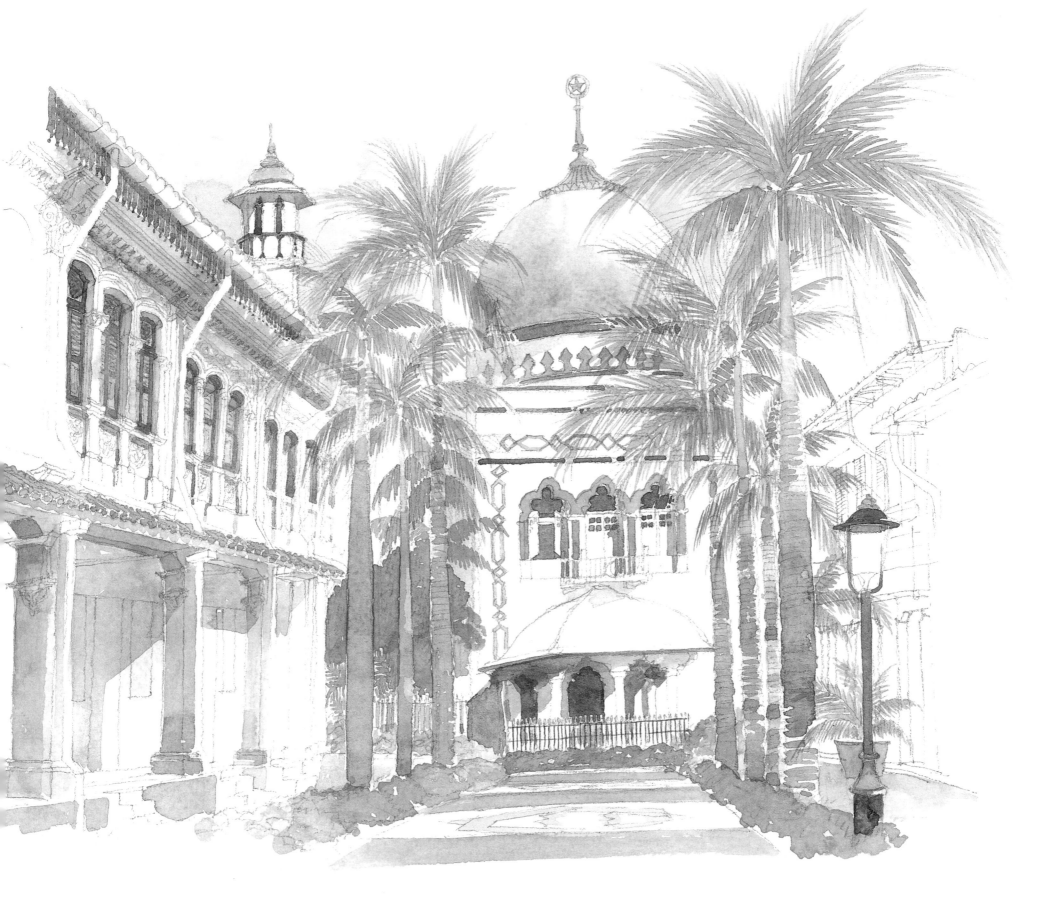

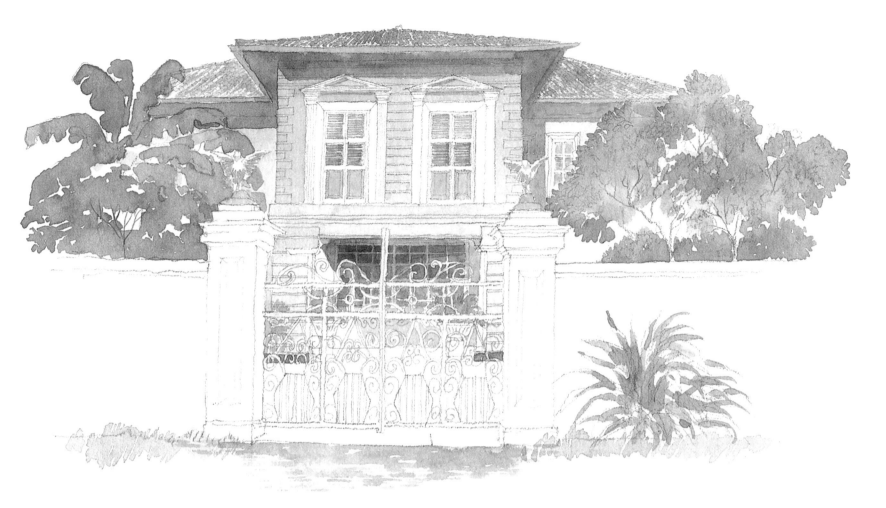

Historic Kampong Glam.
Masjid Sultan (left) has dominated
Kampong Glam since the mid-1920s
and remains a focal point for
Muslims from all over the island.
Here it is framed by the shopfronts
of Bussorah Street. When the
Malay Heritage Centre, or Taman
Warisan Singapura, is completed it will
include a museum housed in the
old Istana Kampong Glam (right),
once the home of the descendents of
Sultan Hussein, who signed the treaty
with Raffles. No. 79 Sultan Gate (above)
known as Gedung Kuning or Yellow
Mansion, will be a restaurant.

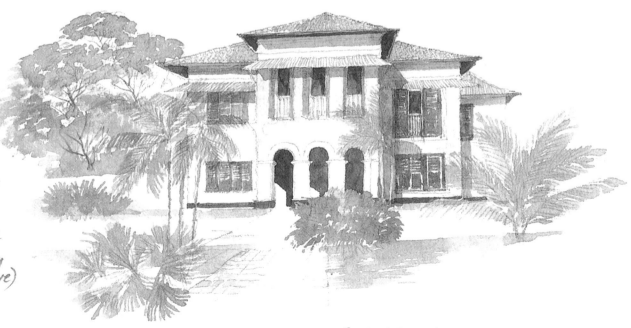

البيع الكوان

Aljunied
Brothers

91

BATIK

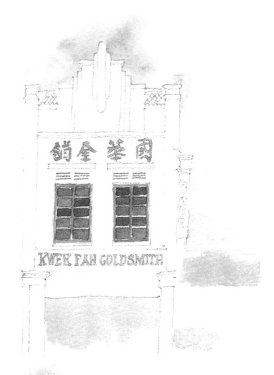

鎗金華國

KWEK FAH GOLDSMITH

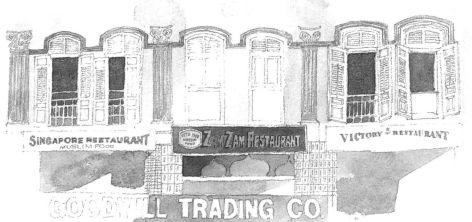

SINGAPORE RESTAURANT
MUSLIM FOOD

ZamZam Restaurant

VICTORY RESTAURANT

GOODWILL TRADING CO.

CHOP GADIA

Old signs with a
fresh look are showing
off their trades alongside
restored buildings.

CHOP KRUSI
Quality
SARONG

GUARANTEE FIRST COLOUR

Amazing colours are appearing
in Kampong Glam, with houses
suddenly coming alive again,
not only with paint but with
new businesses opening up on
every street, together with the
old established names.

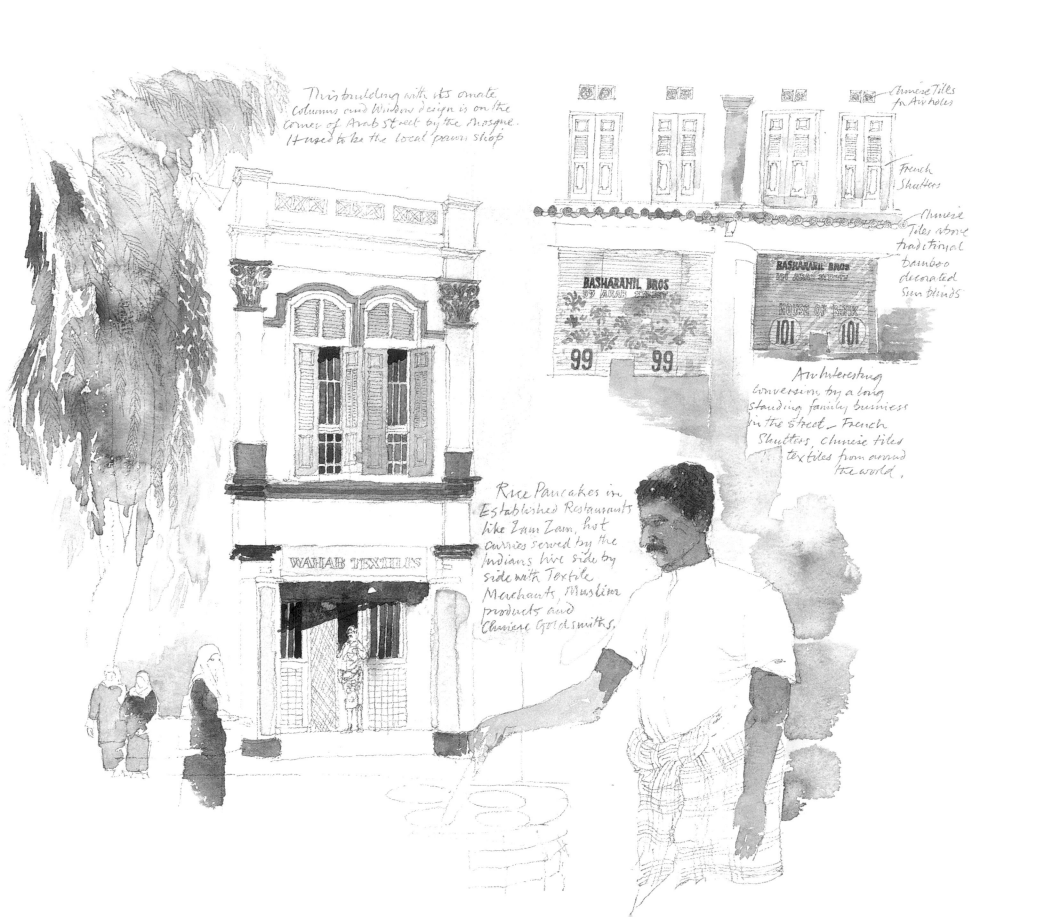

This building with its ornate columns and window design is on the corner of Arab Street by the Mosque. It used to be the local pawn shop.

Chinese Tiles in Air holes

French Shutters

Chinese Tiles above traditional bamboo decorated Sun blinds

BASHARAHIL BROS
99 ARAB STREET

99 99

BASHARAHIL BROS
101 ARAB STREET

HOUSE OF BATIK

101 101

An Interesting conversion by a long standing family business in the street — French Shutters, Chinese tiles, textiles from around the world.

WAHAB TEXTILES

Rice Pancakes in Established Restaurants like Zam Zam, hot curries served by the Indians live side by side with Textile Merchants, Muslim products and Chinese Goldsmiths.

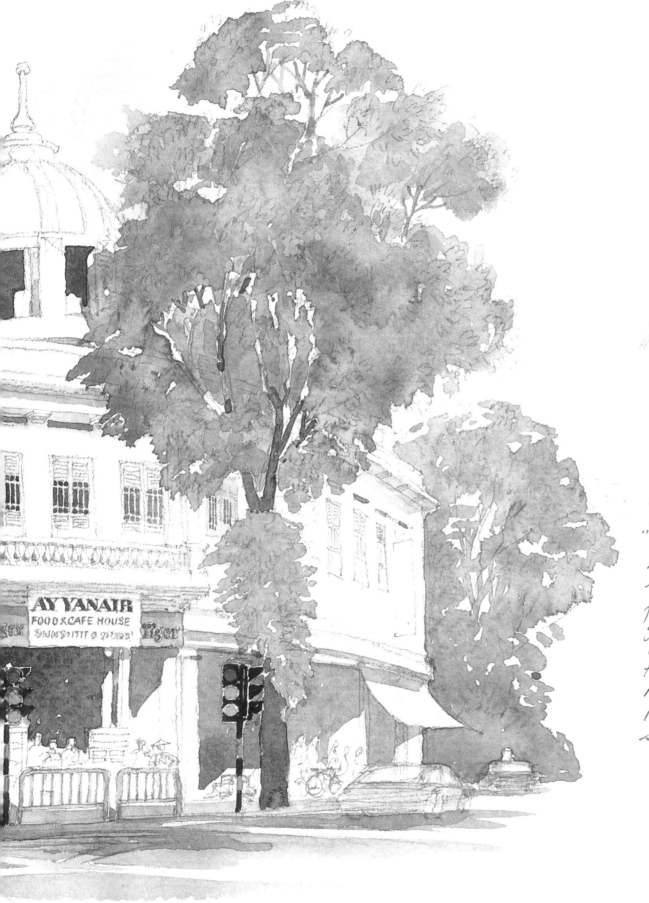

Little India was once described by a
local restaurant proprietor as an
"every-kind-of-people-coming place".
And so it is. A stroll along its streets
is a feast for the senses: the smell of
freshly ground spices, the glitter of
gold jewellery, the bright stacks
of saris piled high, the shoppers in
the emporiums bargaining over all
manner of goods, and the sounds of
Indian music blaring from the stalls
selling the latest from the subcontinent.

ஜோதி ஸ்

SERANGOON ROAD

ANI MANI PORC

FISH HEAD CURRY

Many traditional Indian trades have returned to Little India's restored shophouses, bringing back the assemblage of colours, aromas and sounds that are distinctly Little India.

Sri Srinivasa Perumal Temple is one of Little India's best-known landmarks.

In Kerbau Road, a recently built hawker stall with Indian-style roof shares space with beautifully restored ornate terrace houses.

In a timeless scene, trishaw drivers wait patiently for customers in front of restored Buffalo Road shophouses for shoppers from Zhujiao market laden with foodstuffs.

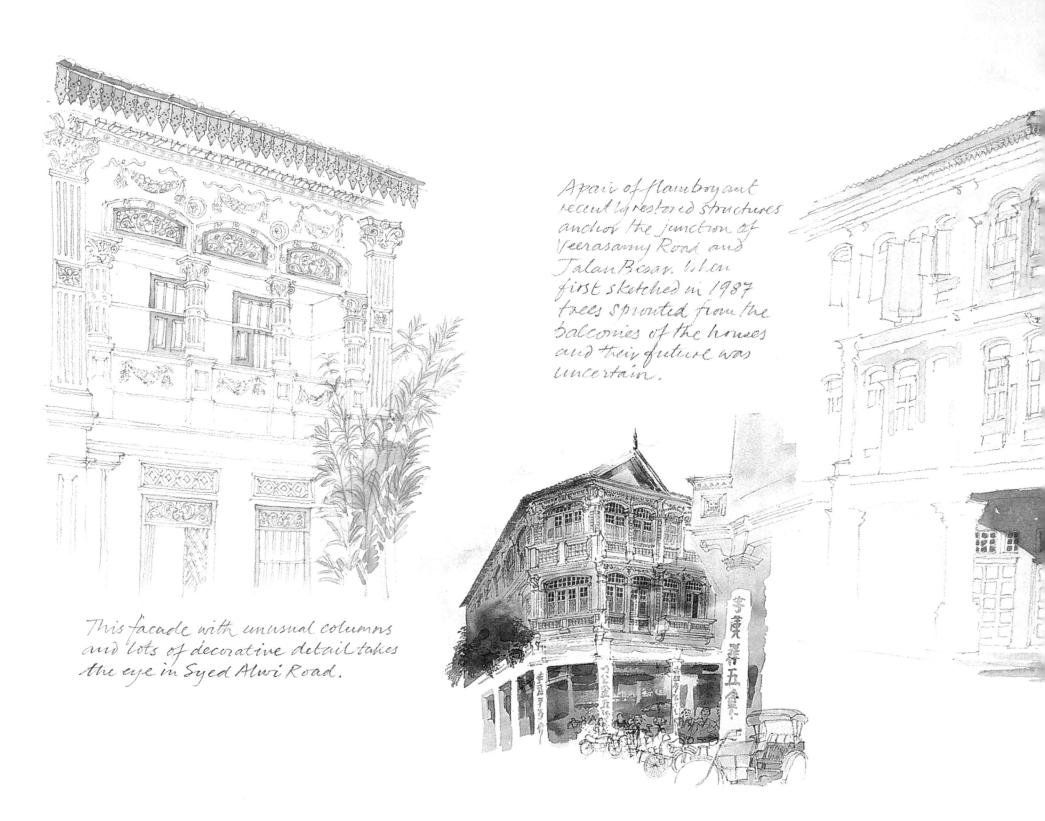

A pair of flamboyant recently restored structures anchor the junction of Veerasamy Road and Jalan Besar. When first sketched in 1987 trees sprouted from the balconies of the houses and their future was uncertain.

This facade with unusual columns and lots of decorative detail takes the eye in Syed Alwi Road.

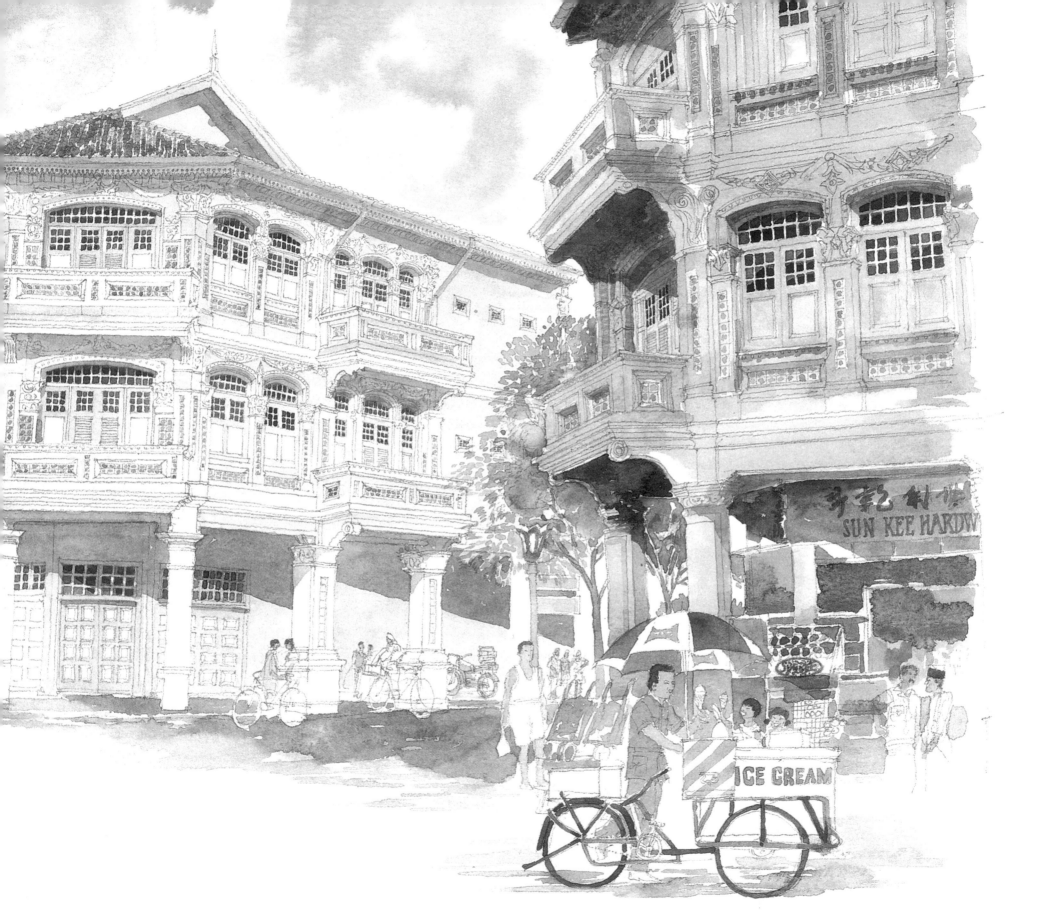

Classic Terraces

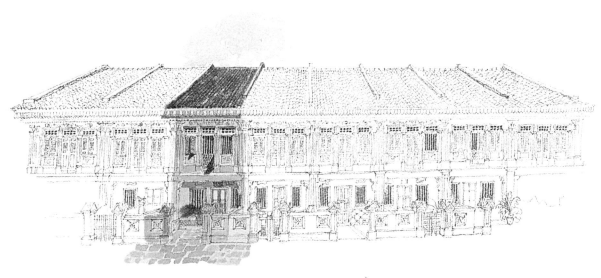

No 12 Koon Seng Road.
Along Koon Seng Road are two
facing rows of highly
ornate terrace houses which
illustrate Singapore's
eclectic Straits Chinese-
influenced domestic
architecture at its best.

Shophouses are narrow, small-scale terraced structures that were typically built in contiguous blocks with individual units sharing party walls. Before the advent of modern construction methods, the shophouse was the predominant building form, not only in Singapore but in most South East Asian towns and cities as well. It was the ideal unit for small-scale family-based business because the ground floor could be used for trade and the upper floors as living quarters.

With suburban expansion and rising affluence in the early years of this century, an increased number of purely residential terraces were erected. This was at a time when good architectural manners consisted of conforming to the established theme. Harmony and grace were attained through the overall unity of the structures, especially the regular proportions of frontages, depths and floor heights. Then onto the shells were crafted a profusion of eclectic details, ranging from Malay fretwork to European classical pilasters, columns, pediments and plasterwork, to air vents in Chinese shapes and decorative scrolls.

Emerald Hill, Blair Road and Koon Seng Road contain classic examples of early 20th-century residential terraces. These are gazetted conservation areas which have experienced a flurry of restoration activity. While the approaches to conservation have varied widely — from the radical altering of the space within a building shell, to a conservative renovation which retains the original spaces and finishes — the enthusiasm of the new owners has been consistent and injected remarkable new vitality into these charming neighbourhoods.

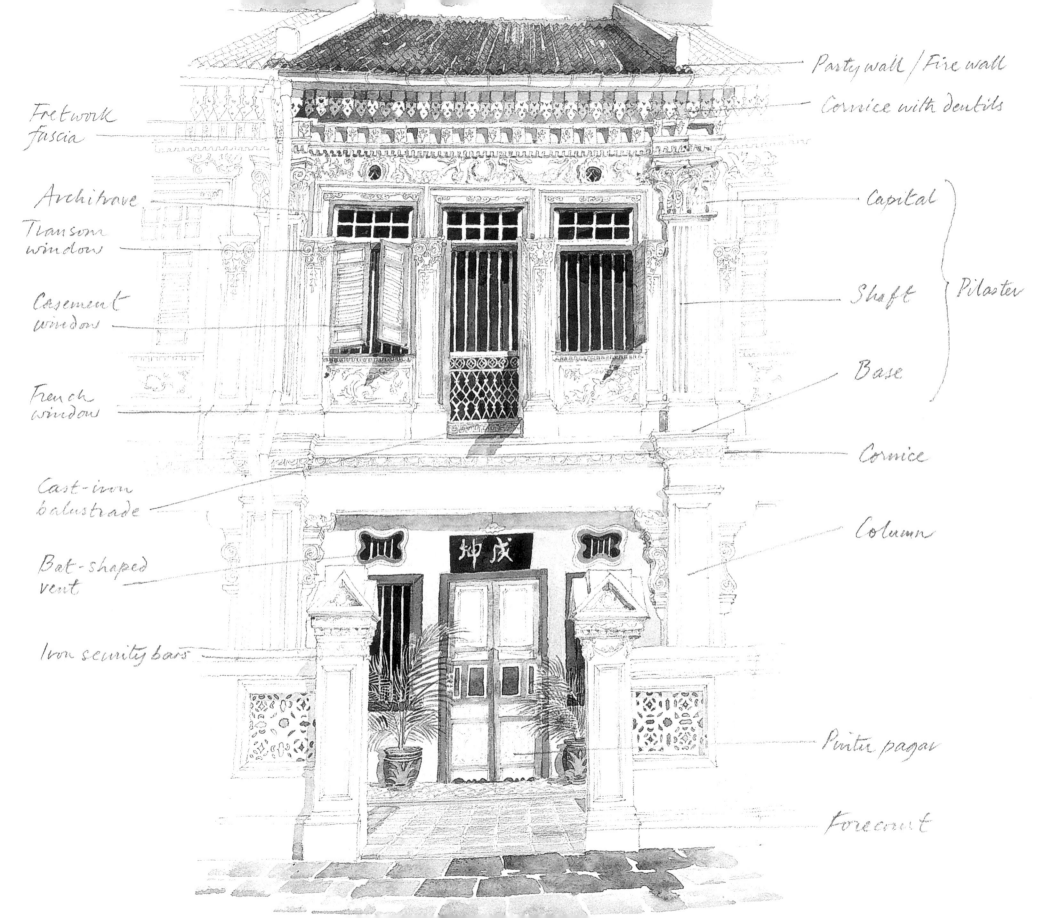

Fretwork fascia

Architrave

Transom window

Casement window

French window

Cast-iron balustrade

Bat-shaped vent

Iron security bars

Party wall / Fire wall

Cornice with dentils

Capital

Shaft — Pilaster

Base

Cornice

Column

Pintu pagar

Forecourt

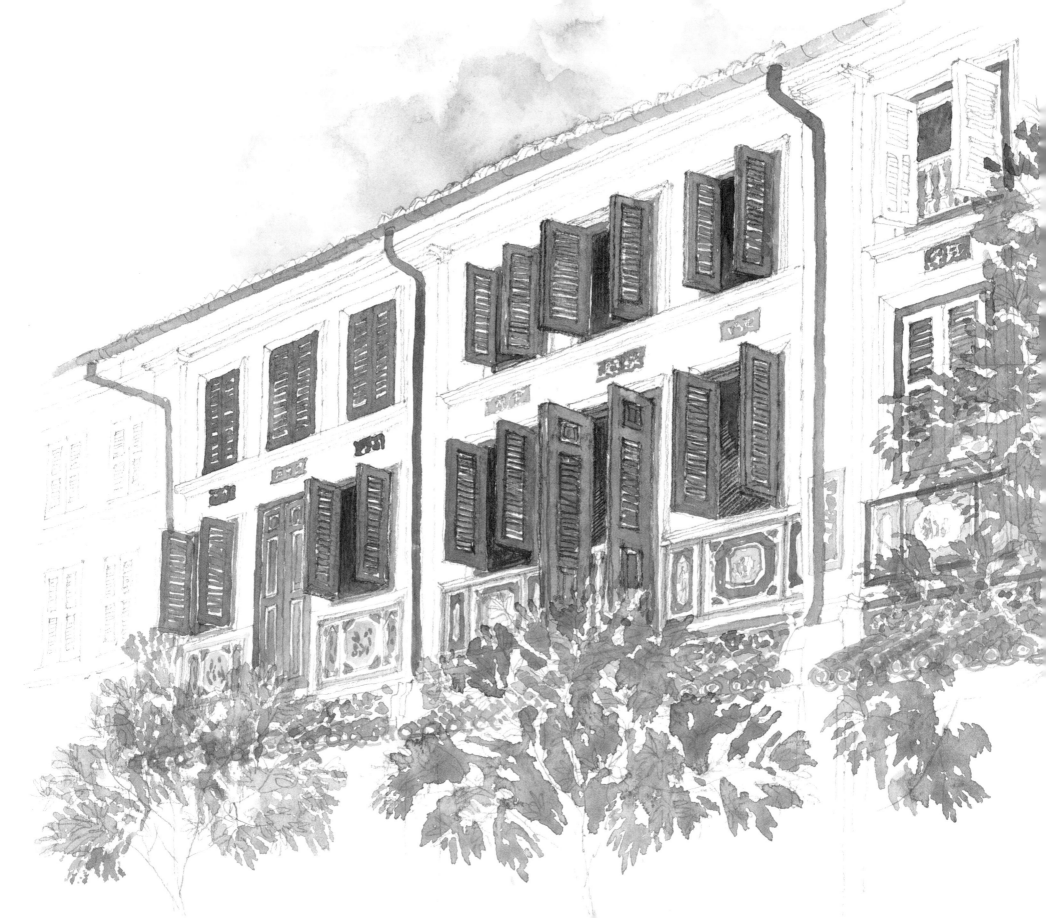

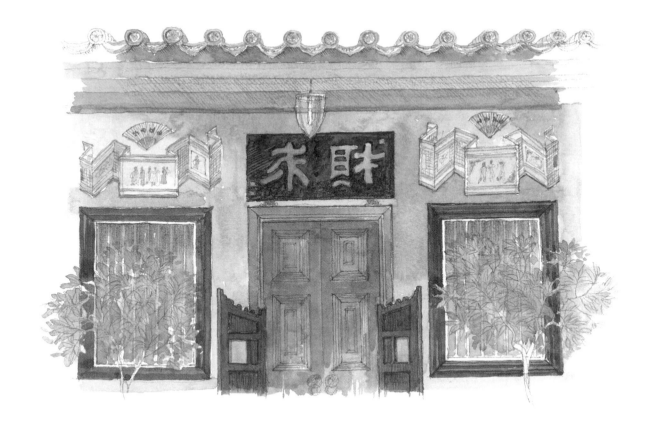

It wasn't long ago
that the houses
along Stanley Street
showed the strains of decades
of overcrowding and neglect, their
elegant Chinese details dimmed by grime an
layers of paint. Buffed and shined, they now
sparkle in the sun. The streets of Chinatown
offer a living architectural museum with
the earlier and more Chinese shophouse
styles, such as these here, abutting all
manner of later interpretations.

The unusual facade (right) is from a robust grouping of early 20th century shophouses along Syed Alwi Road rich in form, texture and decoration. The unique circular windows are similar to those found at Victoria Concert Hall. The house with the gated forecourt is in Emerald Hill, the first designated conservation area, selected in 1981.

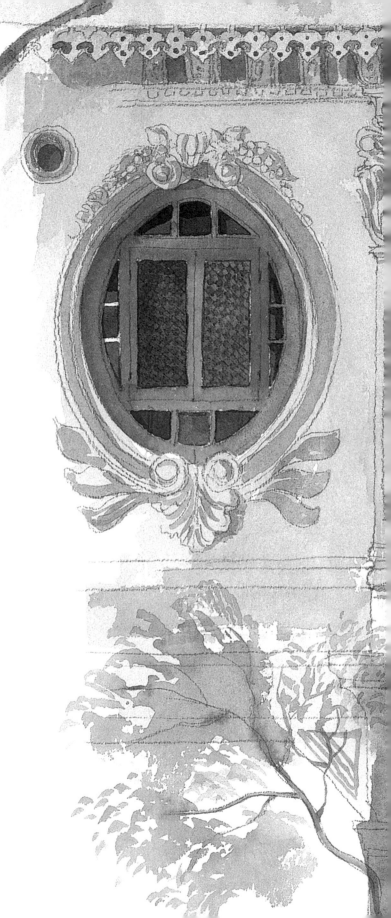

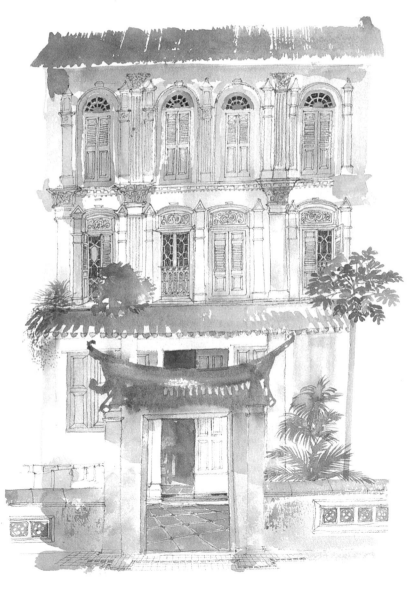

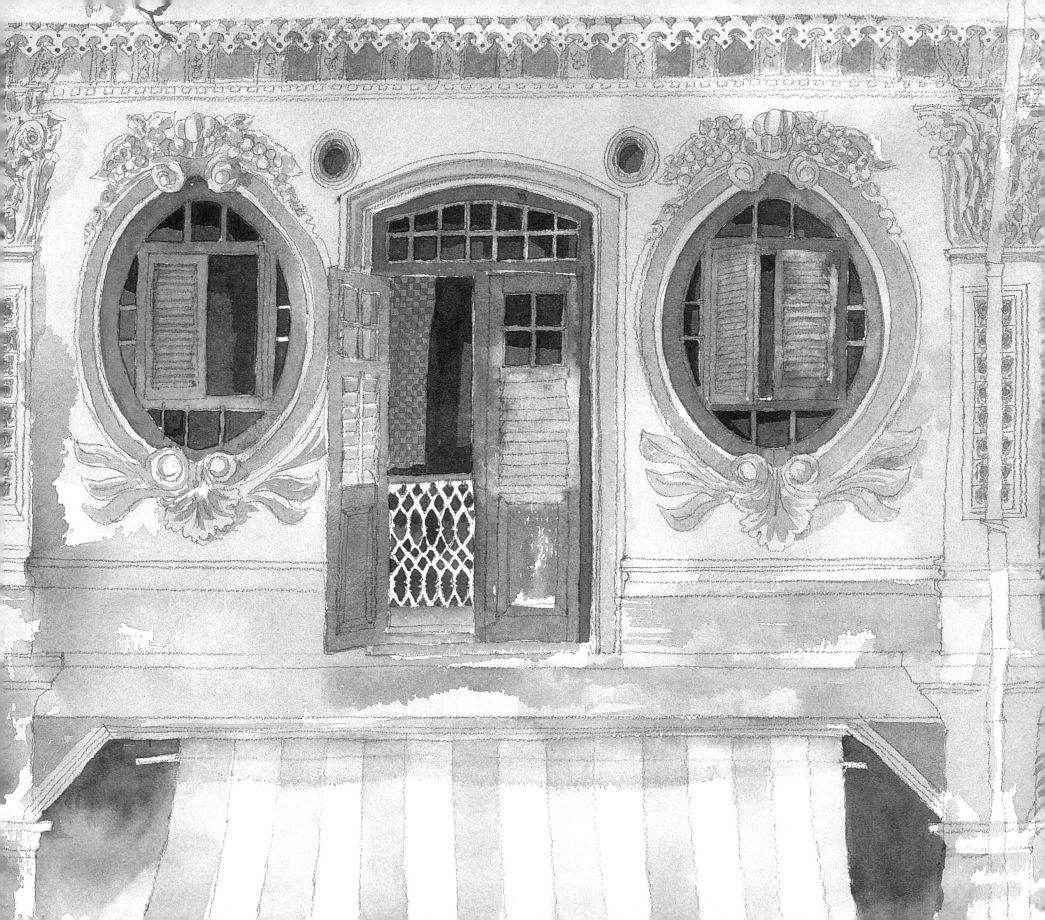

Details such as gate posts, elaborate plasterwork and decorative tiles reveal the richness of Blair Road's houses.

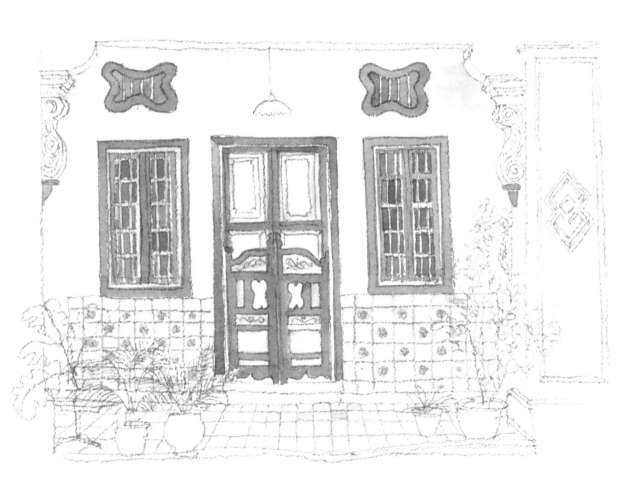

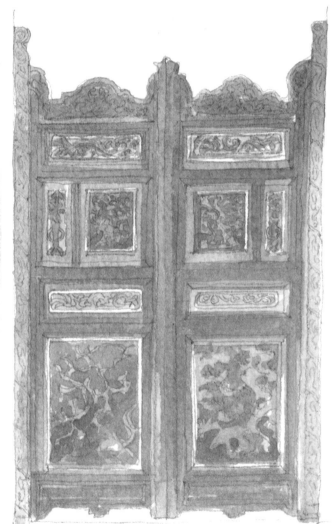

The pintu pagar, or half doors placed in front of main doors, are extremely practical as they afford privacy while giving ventilation when the main door is open.

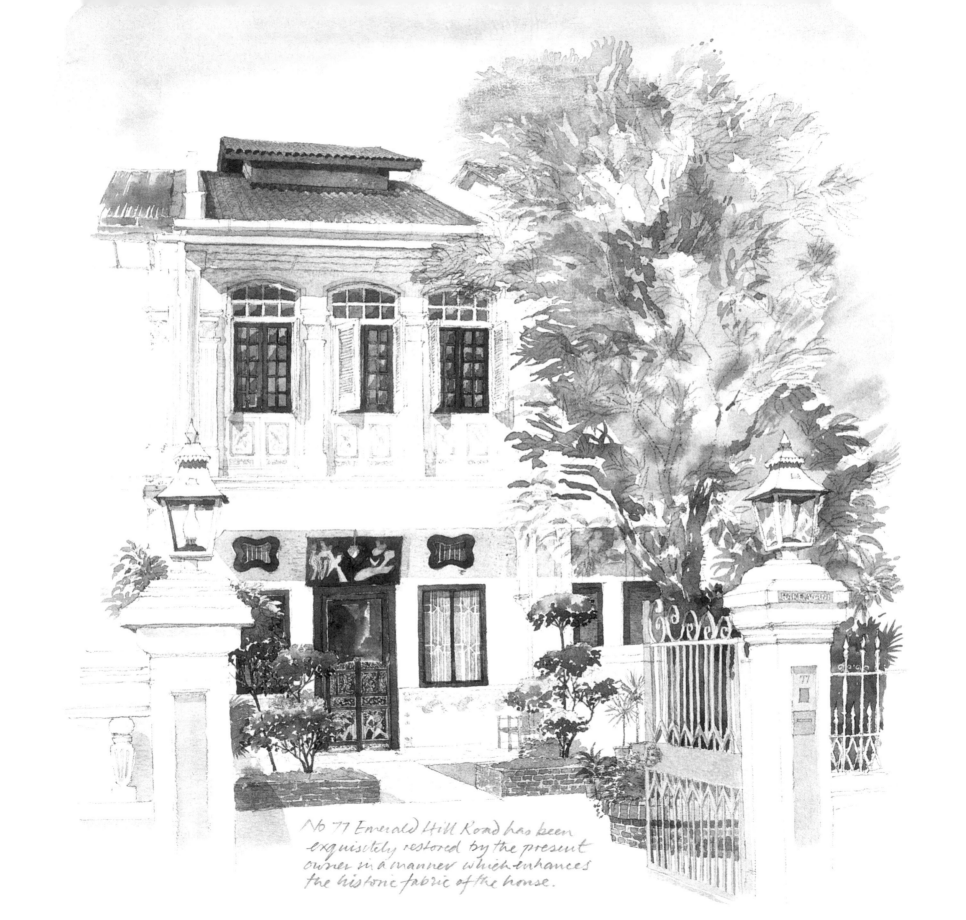

No 77 Emerald Hill Road has been
exquisitely restored by the present
owner in a manner which enhances
the historic fabric of the house.

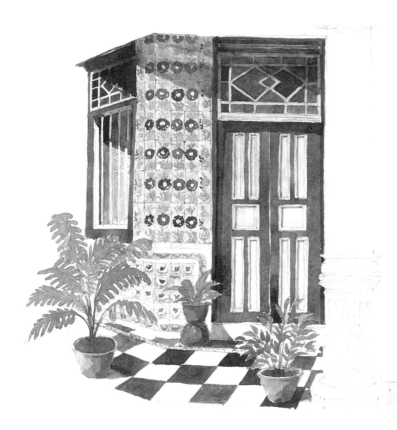

Petain Road (this page) features a row of eighteen terraced houses widely admired for the lavish display of glazed green and pink ceramic floral tiles.

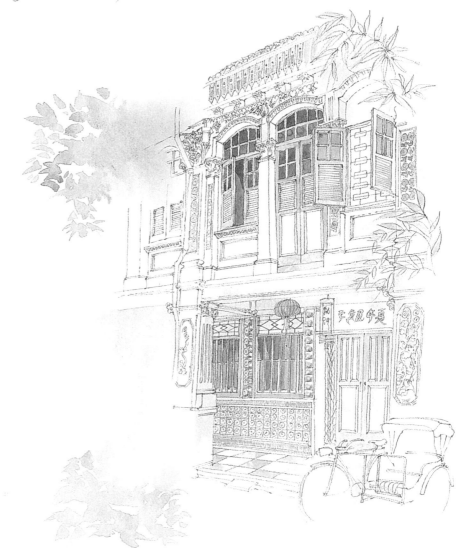

On Desker Road (right) is a shop house in shades of sky and baby blue, jade and apple green, all colours reminiscent of the finely stitched kebayas once worn by Singapore's Nonya ladies.

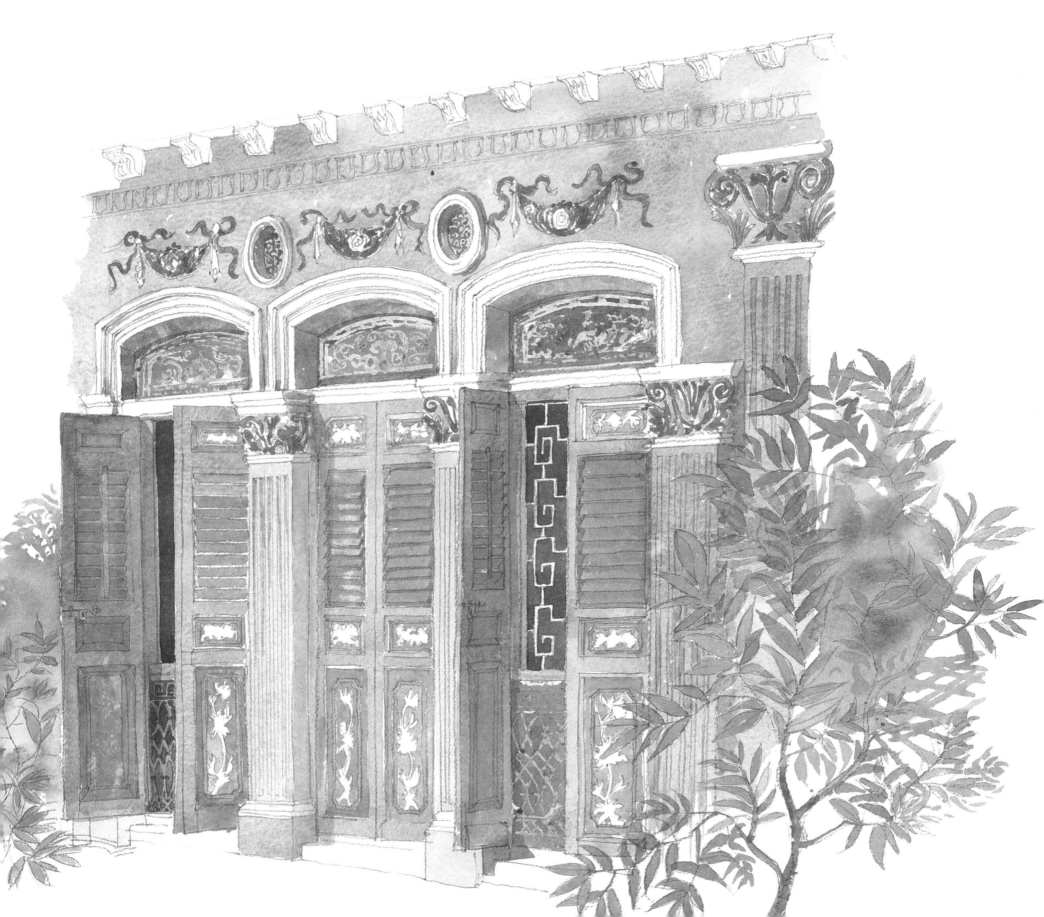

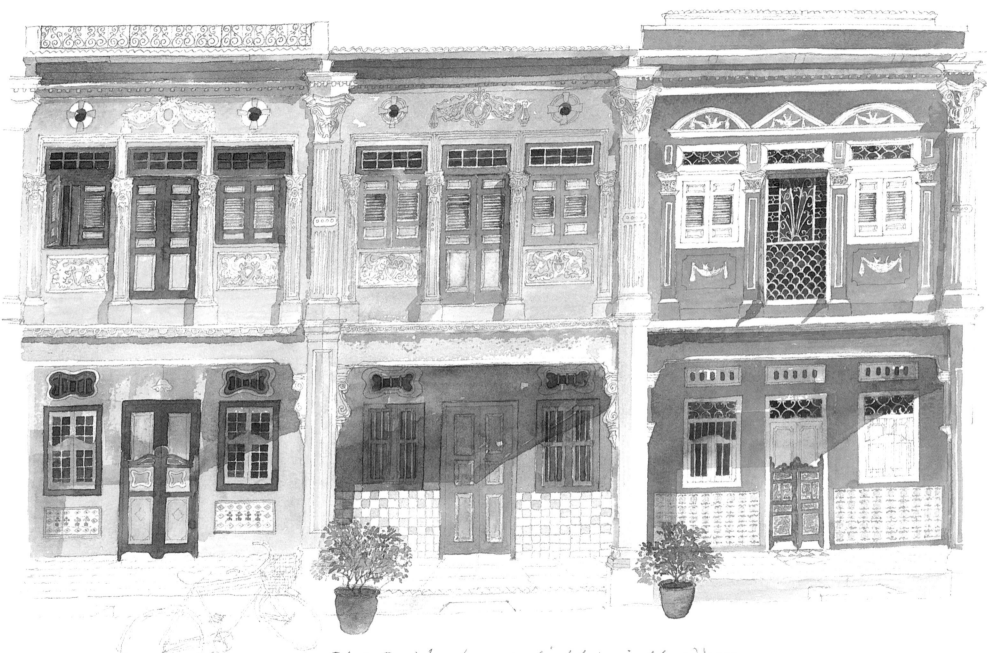

Blair Road has become a highly desirable address.
Here a trio of classic façades along the side
where the houses are linked together
by a five foot way.

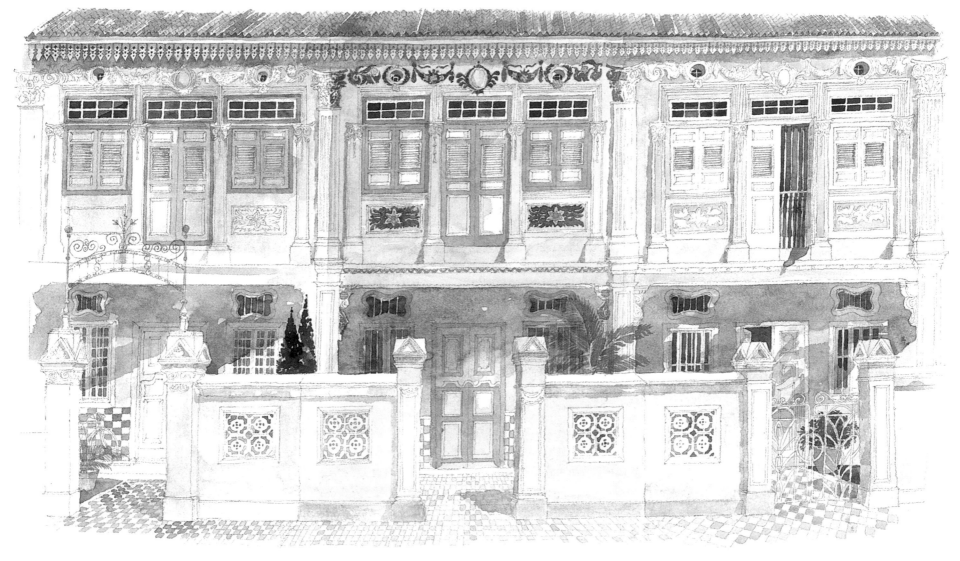

Most of the houses along the opposite side
of Blair Road have generous forecourts.
Among the street's newer occupants
are artists and other creative people
who have easily settled into the
historic neighbourhood.

Island Icons

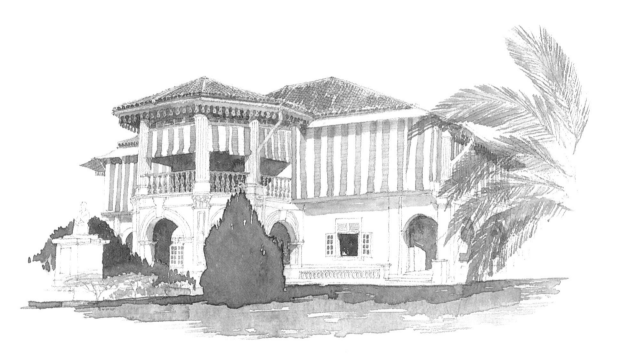

A classic example of the bungalows once found in shady suburbs. The Sun Yat Sen Villa was built in 1902 and is symmetrical in form with porch, verandahs, arches and pseudo-Renaissance features. Once headquarters of Sun Yat Sen's revolutionary movement in Singapore, it is now a museum.

From the gaudy pre-war shophouses along Balestier Road, to the sleek Singapore Improvement Trust flats built in the 1930s in Tiong Bahru, and the gracious black-and-white houses that were once home to colonial civil servants, the island contains great architectural diversity.

Some of the historic structures have found surprising new uses. Among the gems is the recently restored House of Tan Yeok Nee, located just off busy Orchard Road. Built by a wealthy Chinese merchant in the 1880s, the traditional southern Chinese-style courtyard house has been smartly restored as a campus of the University of Chicago Graduate School of Business.

There are many pre-war shophouses still scattered around the island. Visitors are often taken to Joo Chiat or Geylang not only to sample a particular hawker dish or coffee shop specialty, but to enjoy the special atmosphere created by the surrounding shophouses. Built in the 1920s and 1930s, these structures were once virtually rejected in favour of more modern accommodation. They are now sought-after and creatively transformed into comfortable homes for young families.

A distinct type of bungalow associated with colonial Singapore and Malaya is the black-and-white house, a synthesis of the mock-Tudor style and the indigenous Malay kampung house. The style was adopted by colonial engineers who planned several verdant enclaves close enough to town to be convenient, but far enough away so as to feel secluded. The park-like atmosphere was enhanced by curving driveways, judicious planting and the absence of fences and boundary walls.

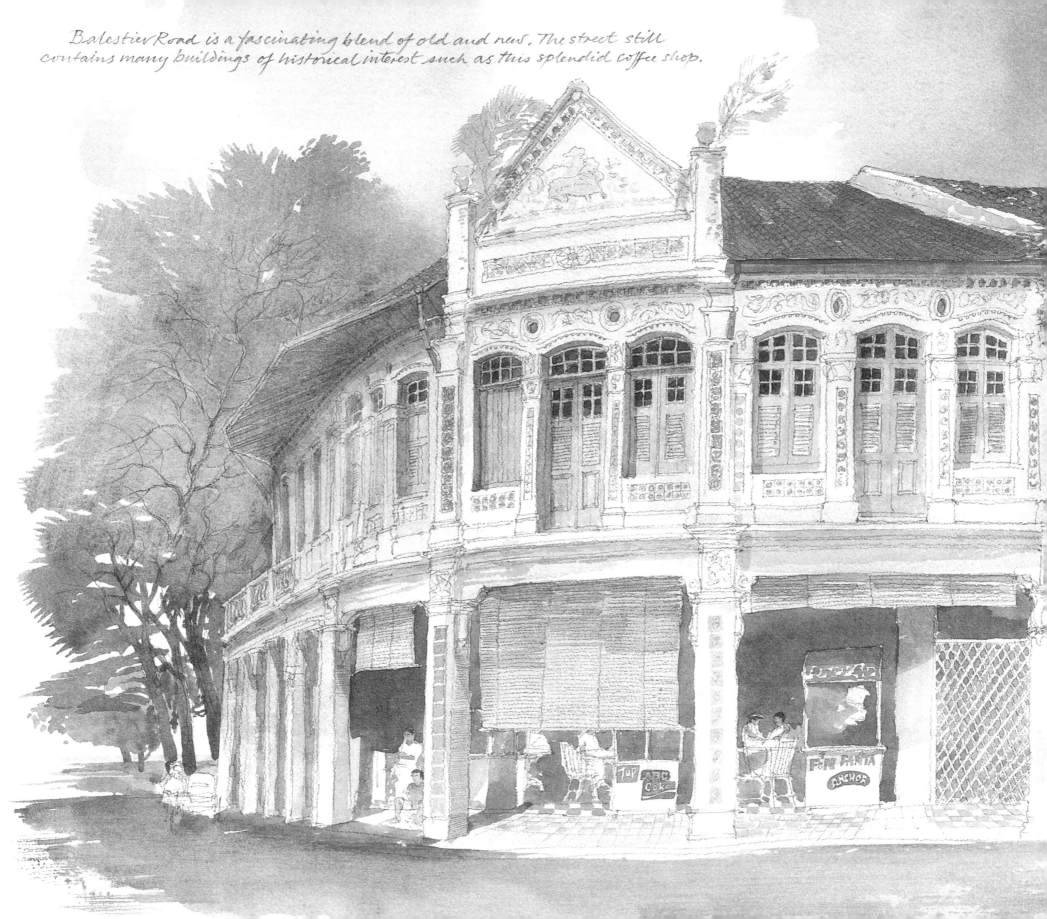

Balestier Road is a fascinating blend of old and new. The street still contains many buildings of historical interest such as this splendid coffee shop.

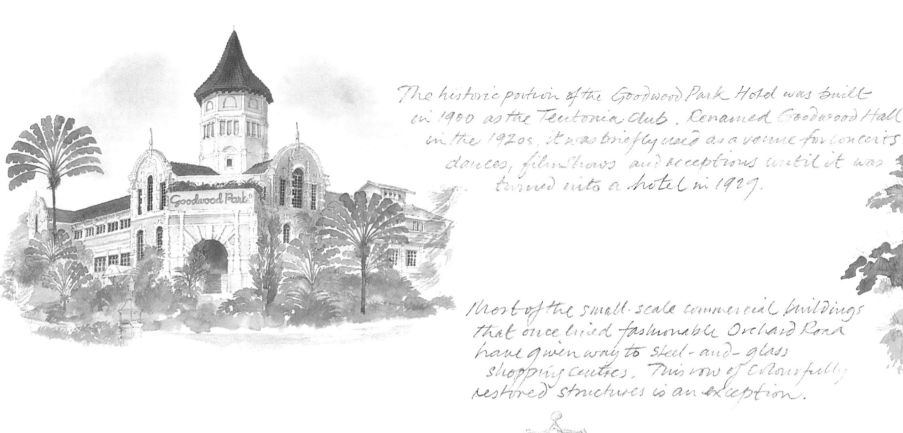

The historic portion of the Goodwood Park Hotel was built in 1900 as the Teutonia Club. Renamed Goodwood Hall in the 1920s, it was briefly used as a venue for concerts, dances, film shows and receptions until it was turned into a hotel in 1929.

Most of the small-scale commercial buildings that once lined fashionable Orchard Road have given way to steel-and-glass shopping centres. This row of colourfully restored structures is an exception.

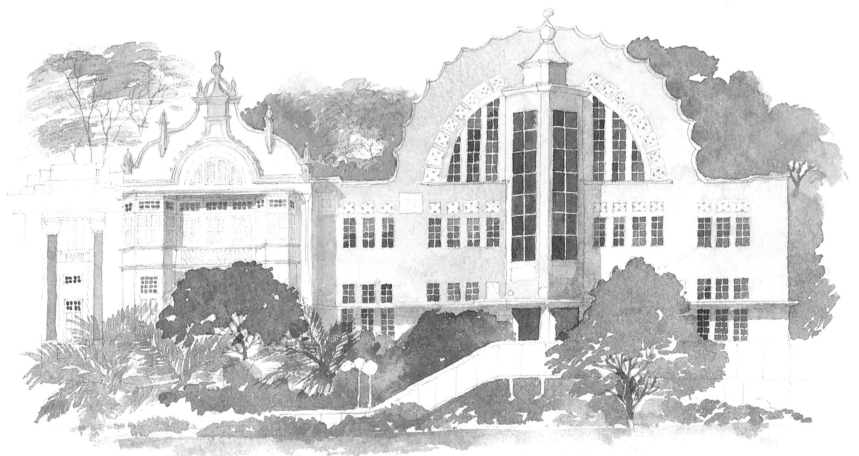

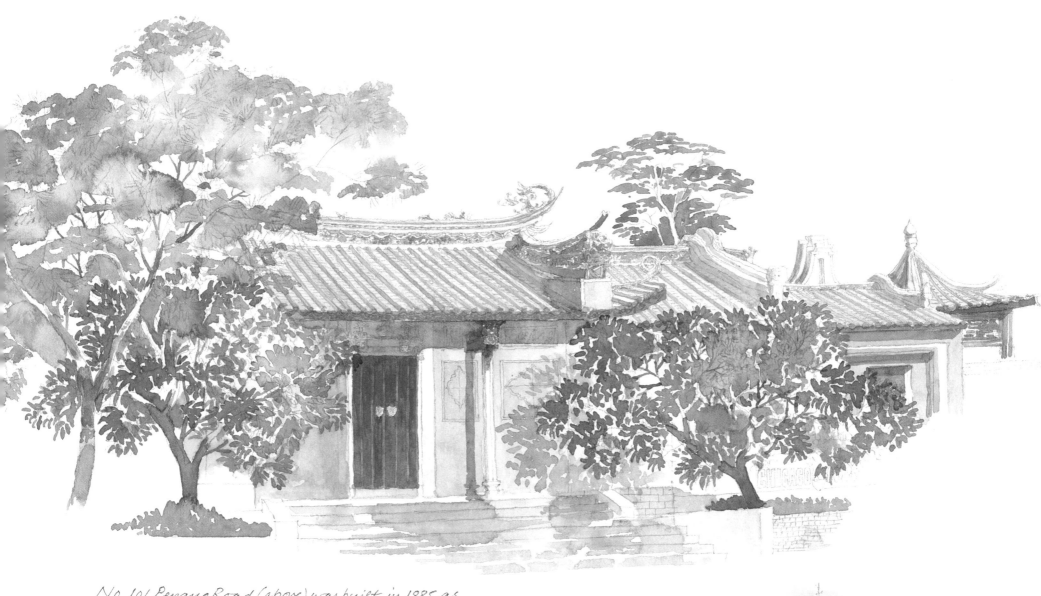

No. 101 Penang Road (above) was built in 1885 as the house of Tan Yeok Nee and restored as a campus for the University of Chicago Graduate School of Business. It is the only surviving example of a Chou Zhou-style courtyard house. The old Telok Ayer Market (right) is an elegant octagonal cast-iron structure imported from Glasgow and erected in 1894. It is now a festival market place.

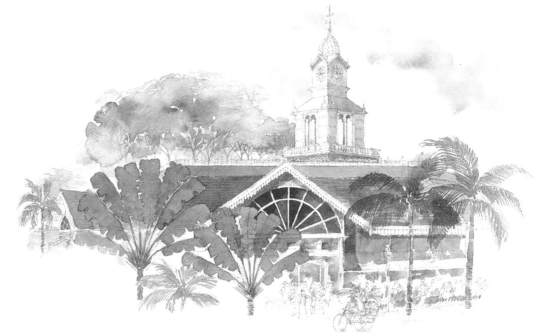

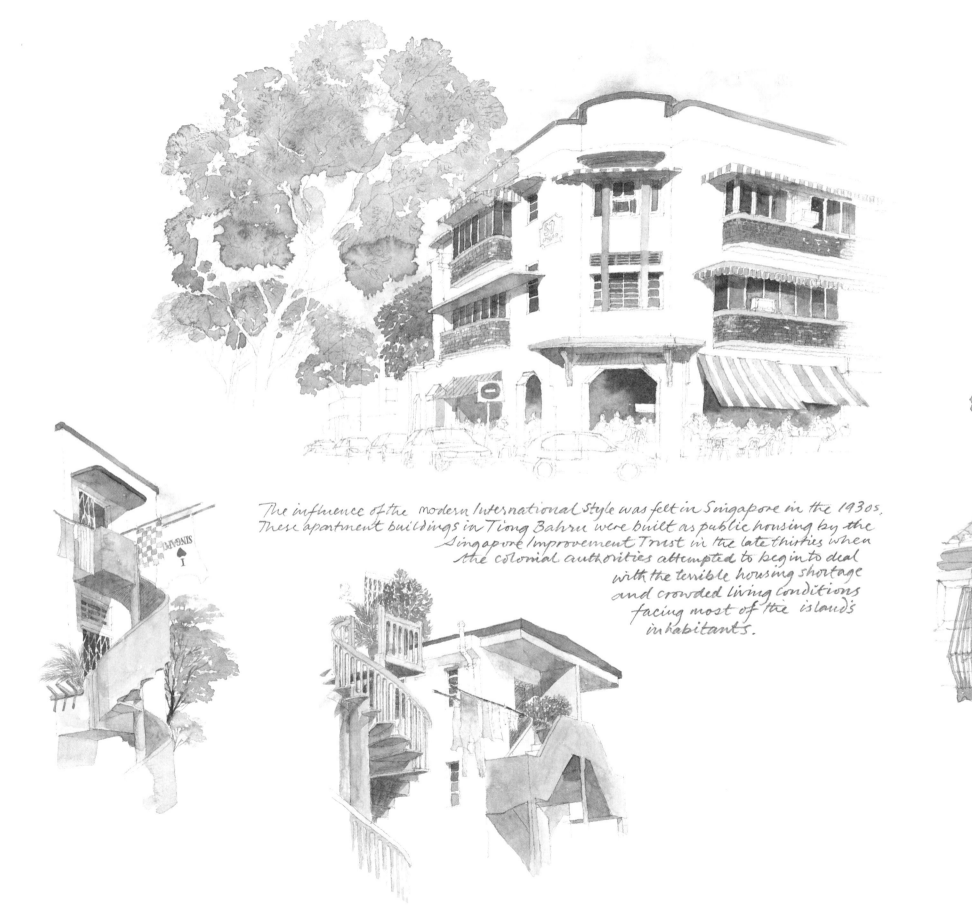

The influence of the modern International Style was felt in Singapore in the 1930s. These apartment buildings in Tiong Bahru were built as public housing by the Singapore Improvement Trust in the late thirties when the colonial authorities attempted to begin to deal with the terrible housing shortage and crowded living conditions facing most of the island's inhabitants.

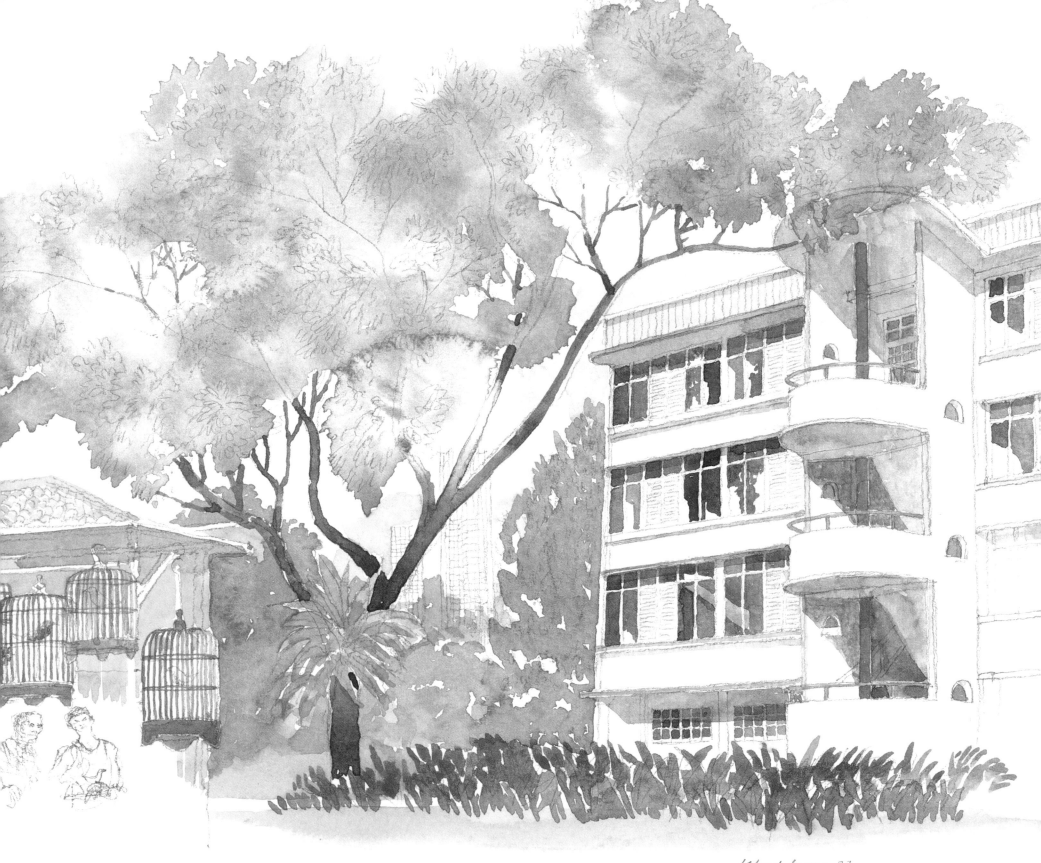

Island Icons 77

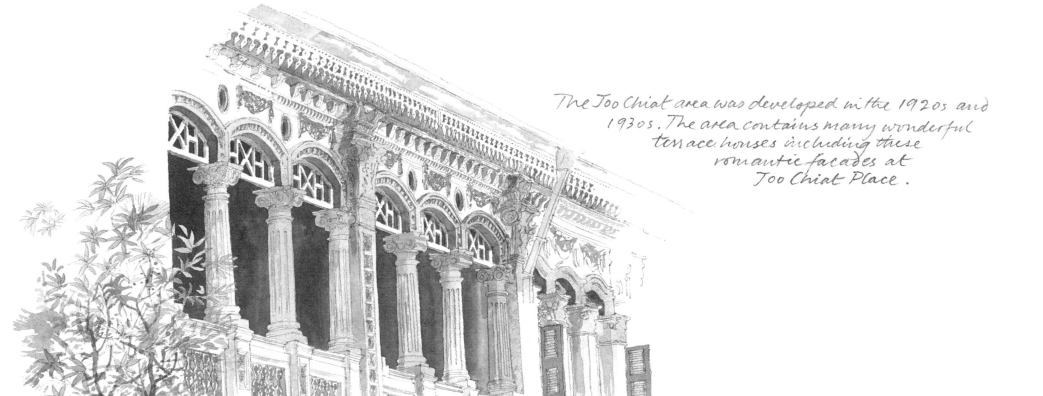

The Too Chiat area was developed in the 1920s and 1930s. The area contains many wonderful terrace houses including these romantic facades at Too Chiat Place.

The Katong Bakery & Confectionery Company was an East Coast landmark, known as The Red Bakery by cognoscenti.

In Geylang imposing Sikh Guards carefully crafted in plasterwork, stand sentinel in the panels of this elaborate concoction at the corner of Lorong 19 and Lorong Bachok (right).

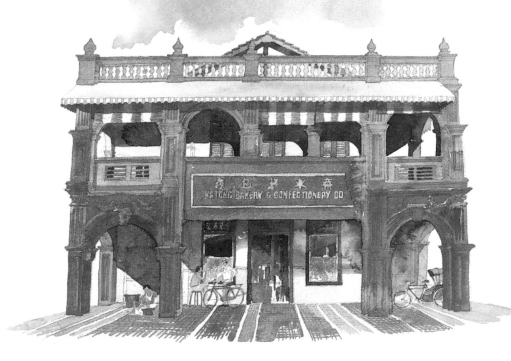

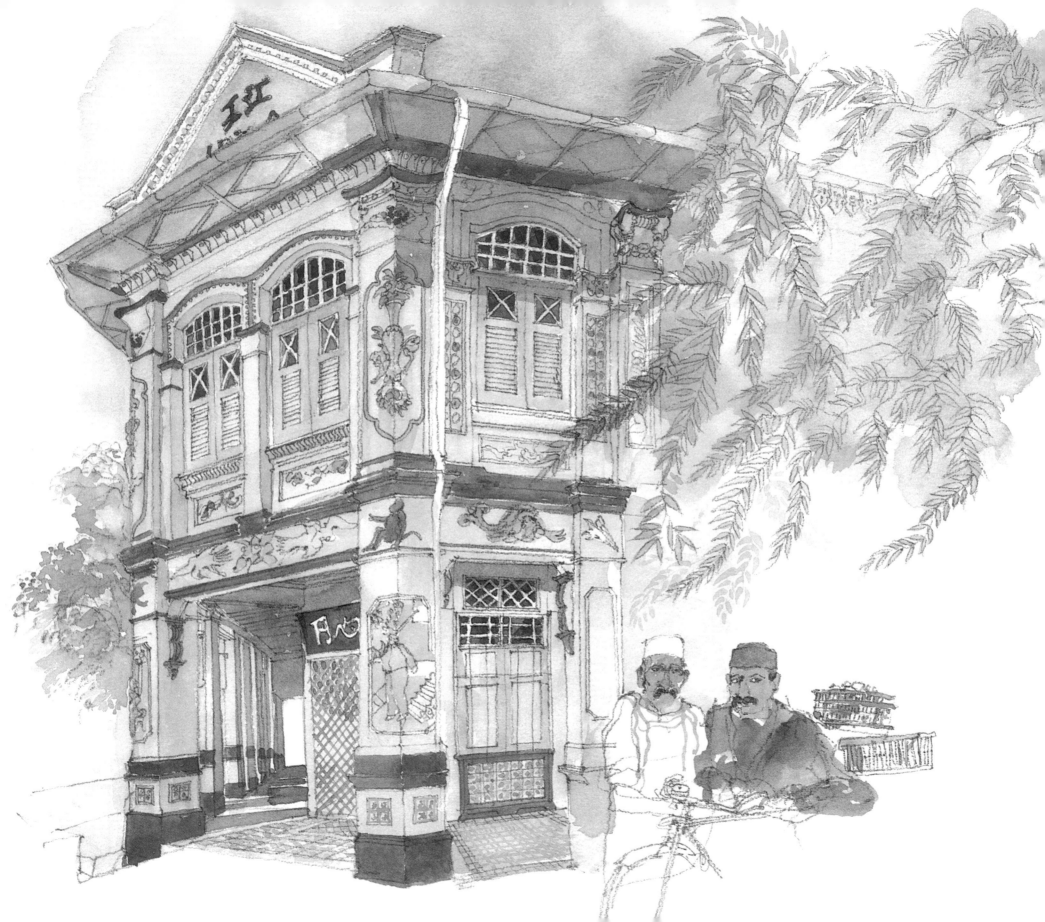

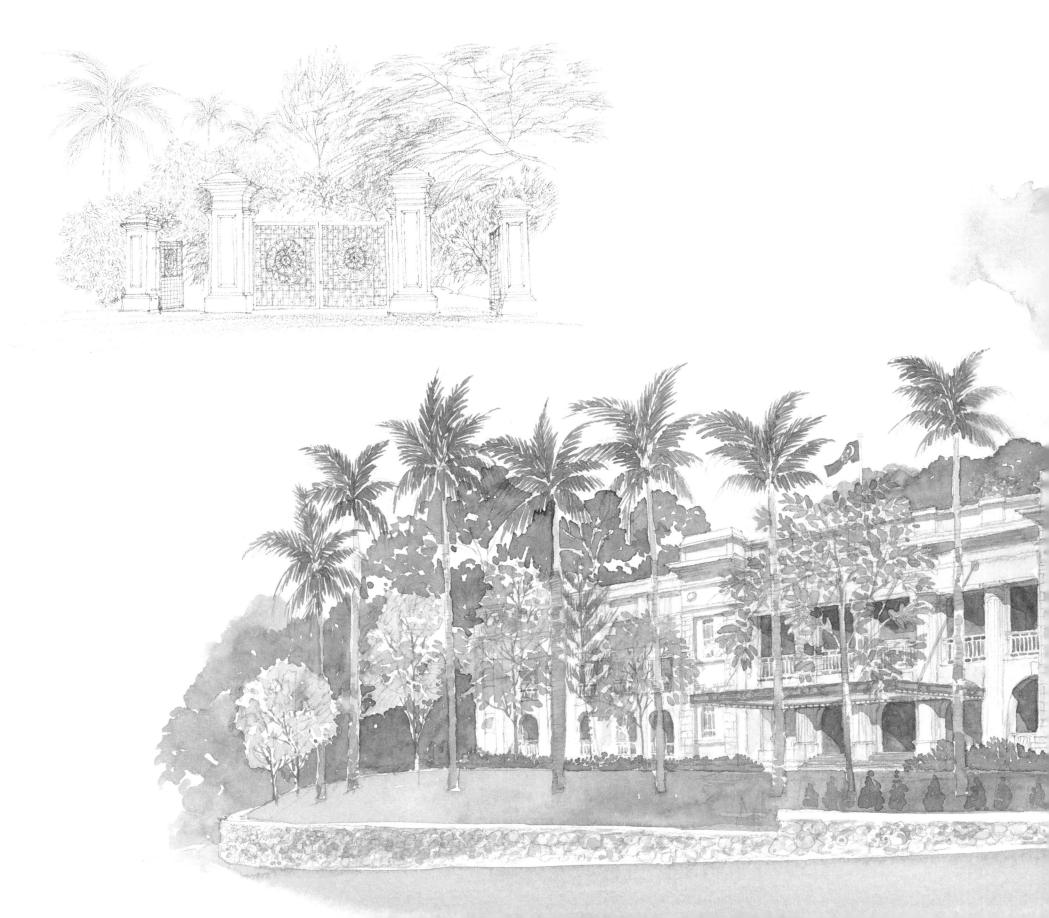

At the crest of what was once called Mount Harriet, in shady Tanglin, is the Old Tanglin Officers' Mess Building. Here British troops cleared the grounds of a defunct nutmeg plantation to set up the Tanglin Barracks in 1861. The original timber and attap Officers' Mess was replaced in the 1930s with this neo-classical building. After the withdrawal of British troops from Singapore in 1971, the area became the Ministry of Defence. Restored between 1999-2001, it is now the headquarters of the Ministry of Foreign Affairs. Across the road are the gates to Singapore Botanic Gardens (left)

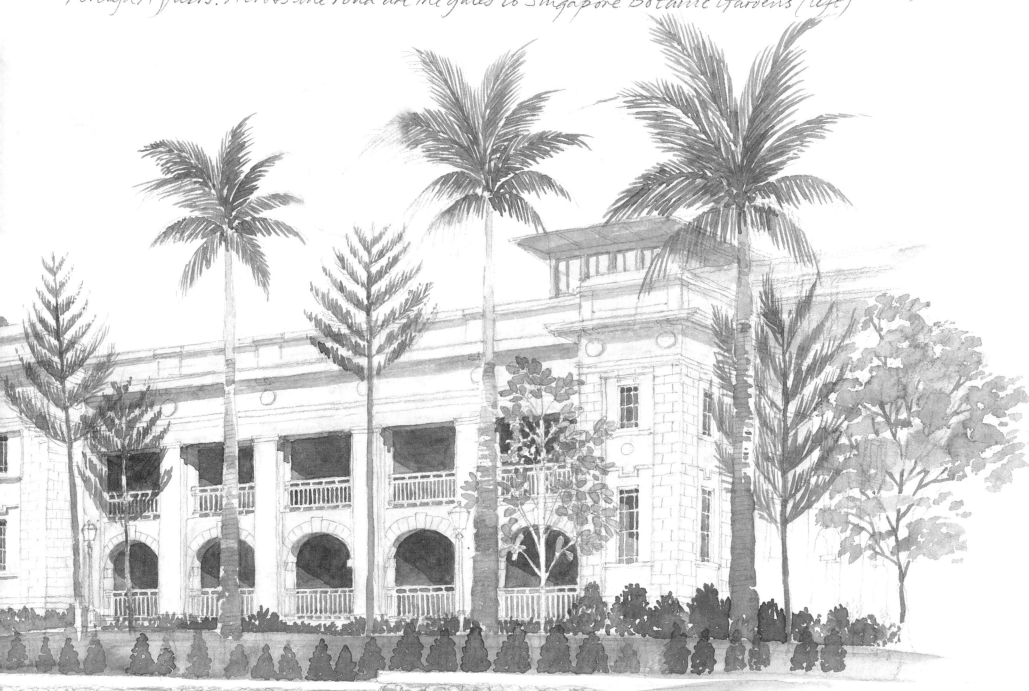

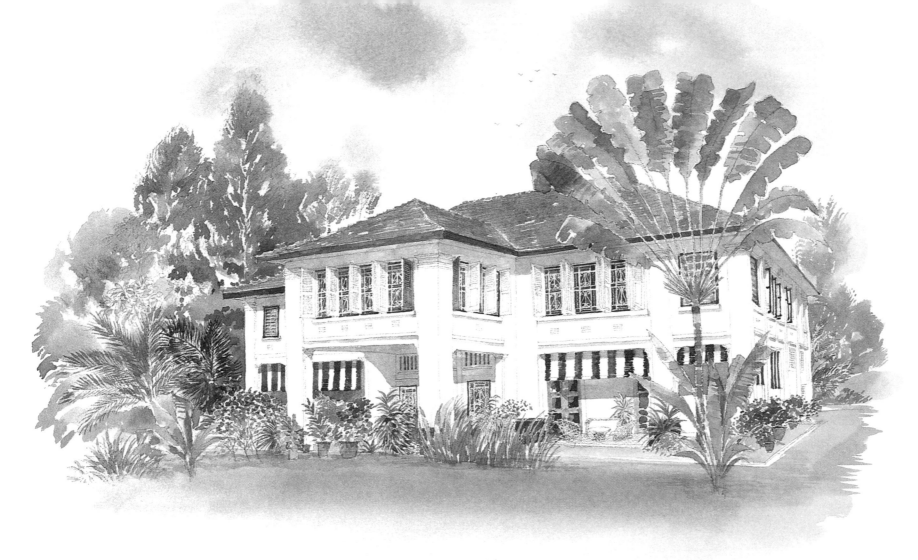

No 6 Cornwall Road is a typical example of the handsome bungalows found in Alexandra Park.

Built in 1936 as an officers' mess this Alexandra Park bungalow was, until mid 1995, the premises of Winchester School.

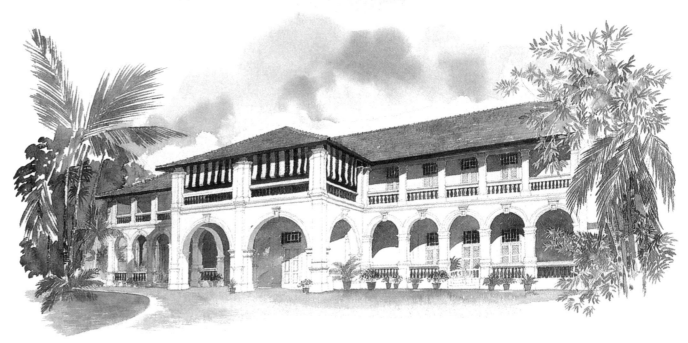

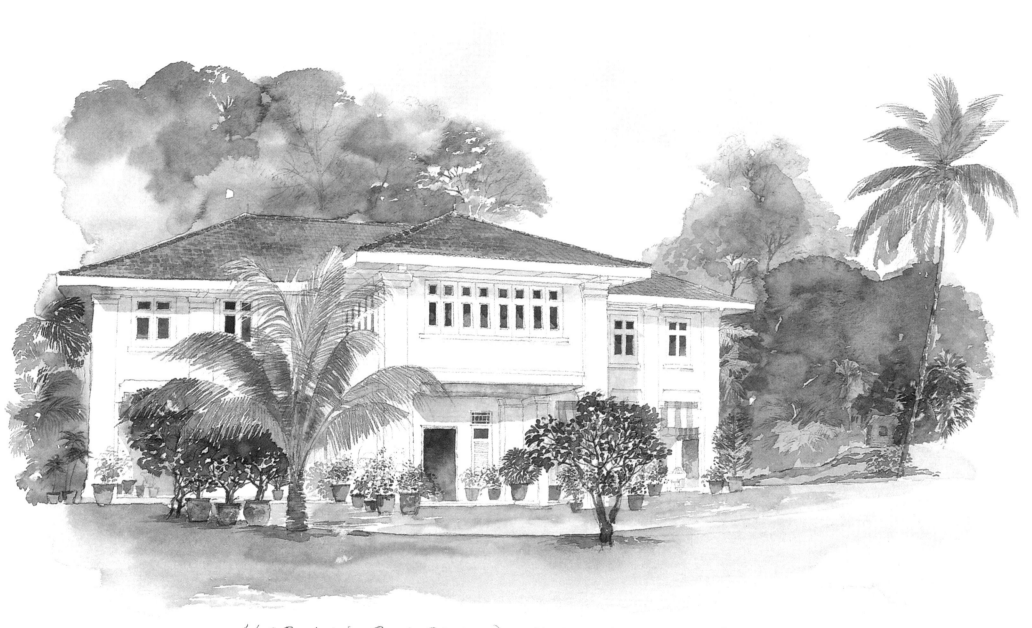

No 5 Berkshire Road. Black-and-white bungalows originated
as a synthesis of the mock-Tudor and indigenous Malay kampong houses.
The style was adopted in various guises by colonial government
engineers who designed the houses for government servants in
places such as Goodwood Park, Adam Park, Malcolm Road
Ridley Park and Alexandra Park.

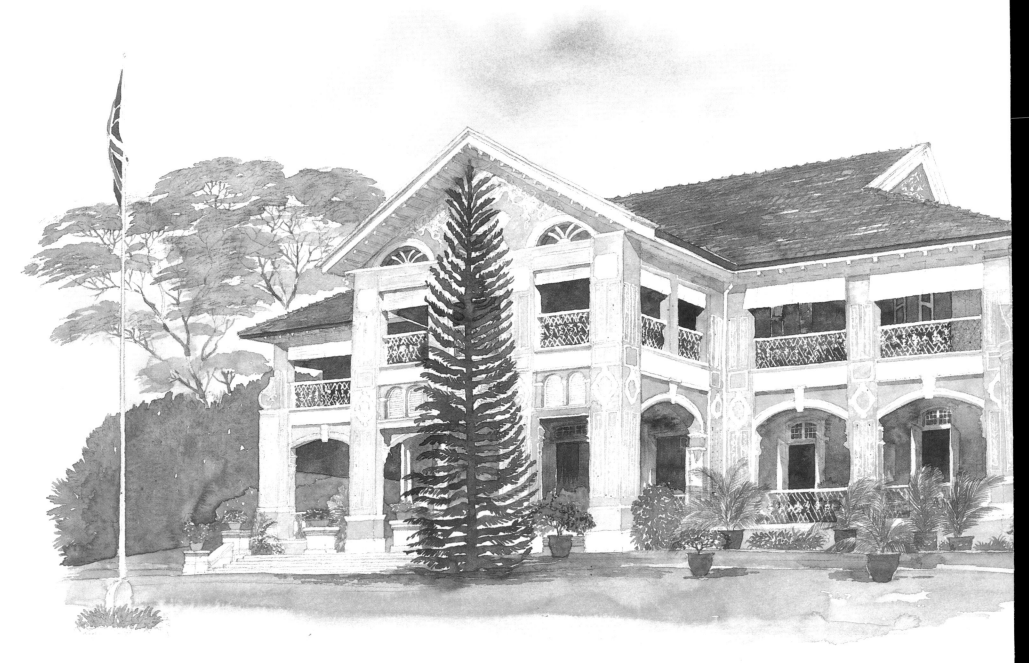

Eden Hall, the residence of the British High
Commissioner to Singapore, was built in 1904.
Beautifully situated in Nassim Road, it
contains a charming garden room overlooking
a paved terrace.

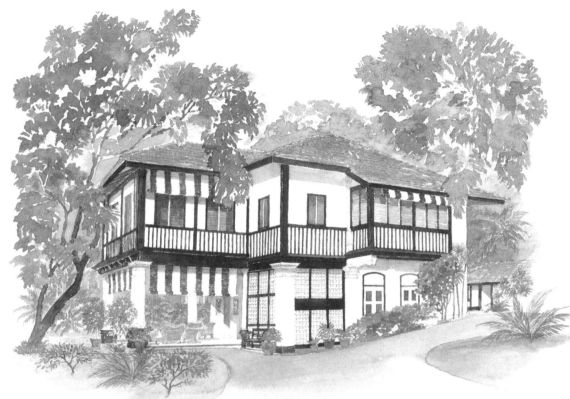

Just a short walk from Orchard Road, and often hidden by lush gardens, are numerous black-and-white houses including this early example on Seton Close.

Burkill Hall is another early example. Built within the grounds of the Botanic Gardens in 1886, it served as the home of several directors of the gardens.

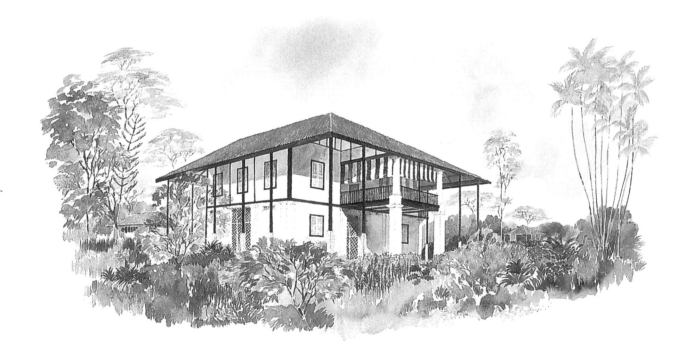

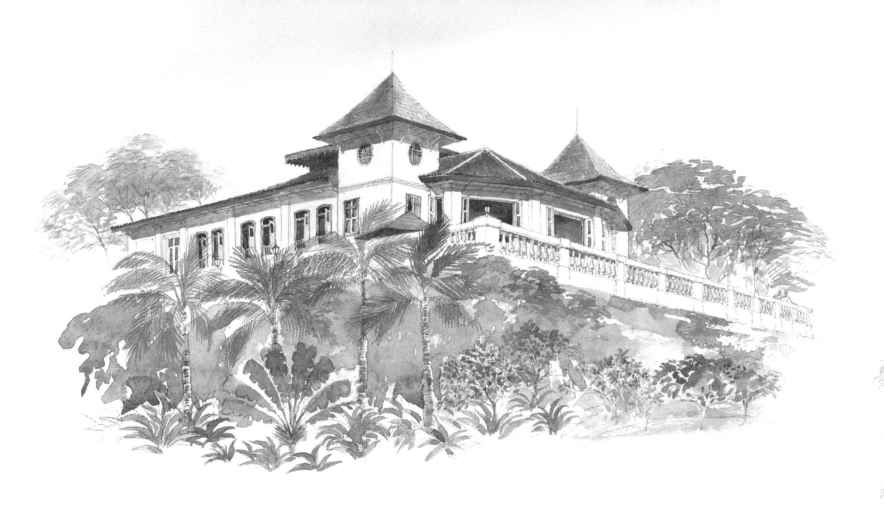

Alkaff Mansion (above) was built
in the early years of the 20th century
by Syed Abdul Rahman Alkaff as a
family retreat. The house was abandoned
after World War Two, rediscovered in the
1980s and has been restored as a unique
restaurant.

Bungalows with Straits Chinese flavour
set within neat garden compounds such
as this one along Mountbatten Road
have become a rare sight in the
suburbs (right).

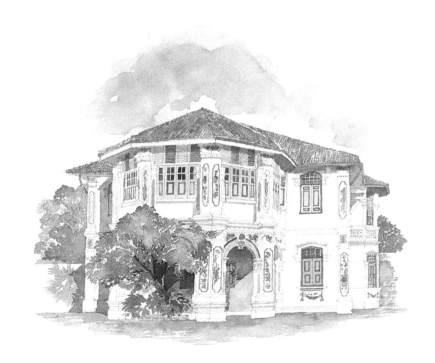

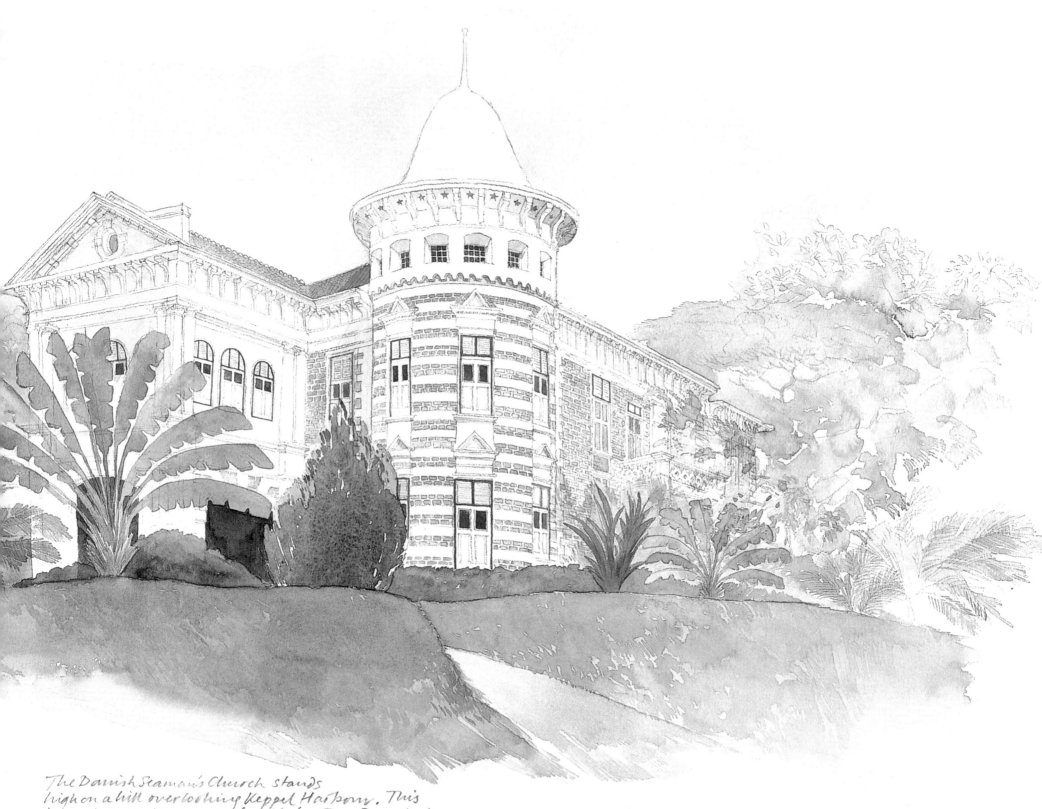

The Danish Seaman's Church stands
high on a hill overlooking Keppel Harbour. This
imposing residence was built by Tan Boon Liat,
grandson of important Hokkien pioneer Tan Tock Seng
in the early years of the 20th century.

Island Icons 87

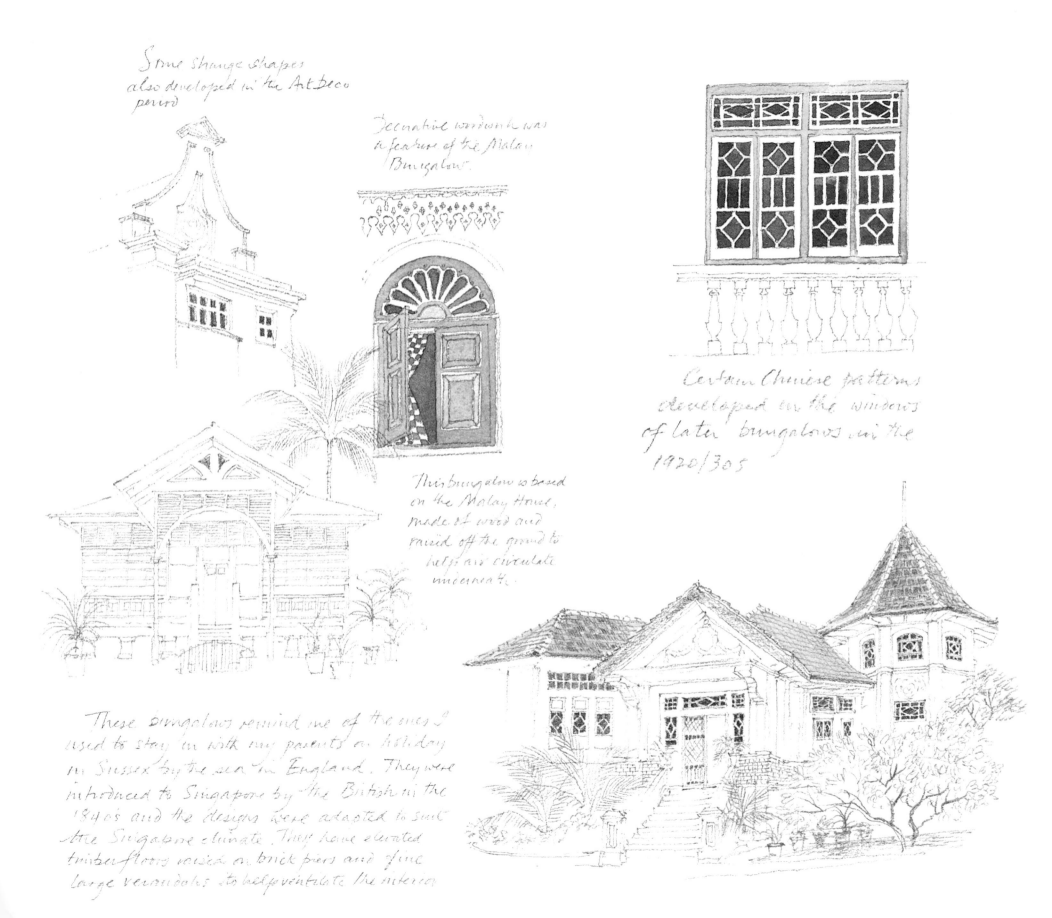

Some strange shapes also developed in the Art Deco period

Decorative woodwork was a feature of the Malay Bungalow.

This bungalow is based on the Malay House, made of wood and raised off the ground to help air circulate underneath.

Certain Chinese patterns developed on the windows of later bungalows in the 1920/30 s

These bungalows remind me of the ones I used to stay in with my parents on holiday in Sussex by the sea in England. They were introduced to Singapore by the British in the 1840's and the designs were adapted to suit the Singapore climate. They have elevated timber floors raised on brick piers and fine large verandahs to help ventilate the interior.

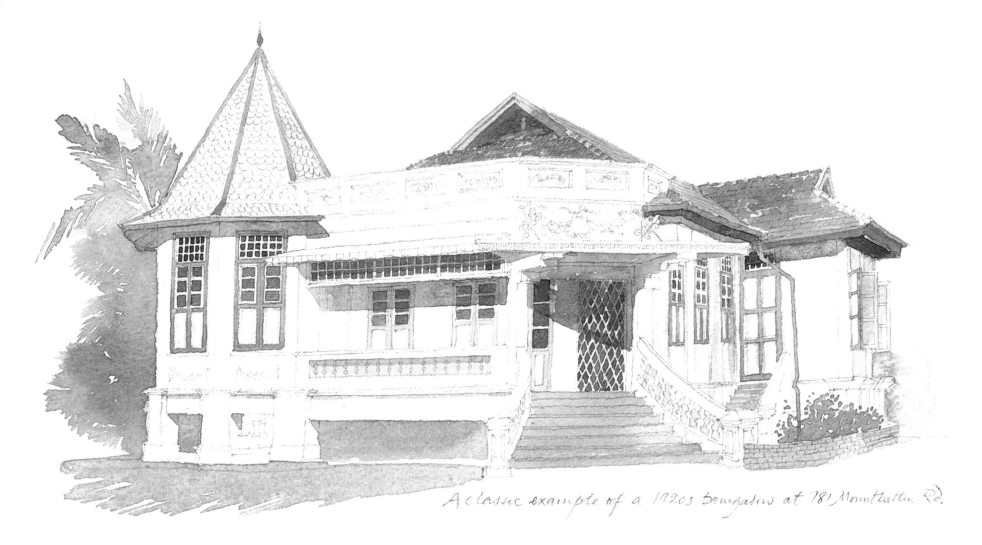

A classic example of a 1920s bungalow at 781 Mountbatten Rd.

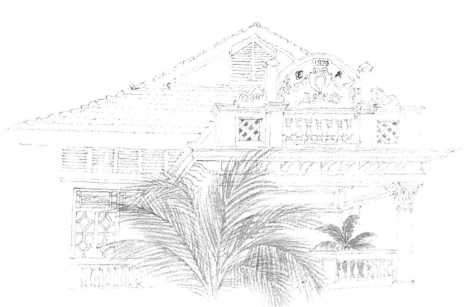

A very grand verandah.
An indulgent 'extra' was built in 1929 to elevate the ordinary bungalow above its neighbours.

Island Icons 89

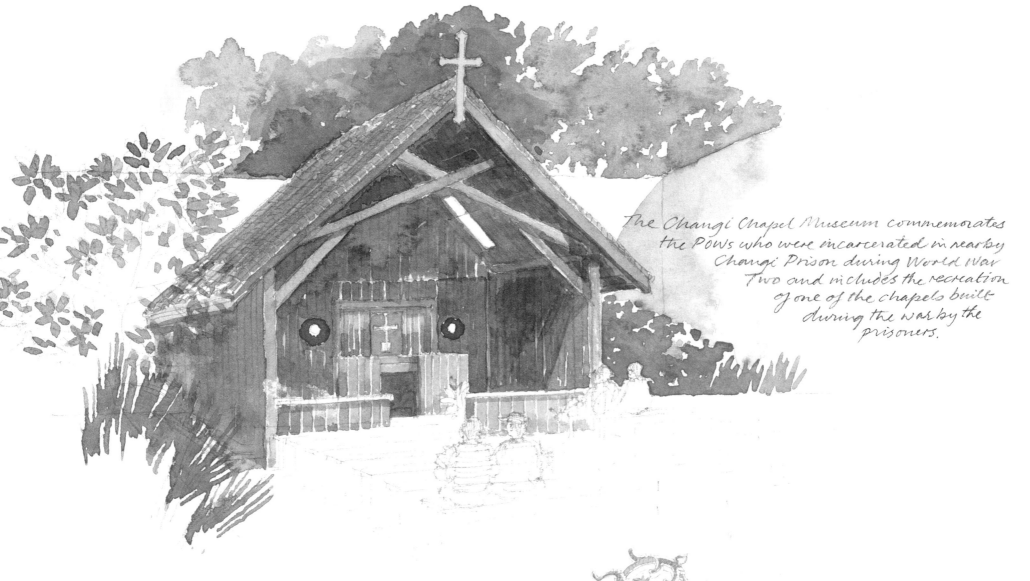

The Changi Chapel Museum commemorates the POWs who were incarcerated in nearby Changi Prison during World War Two and includes the recreation of one of the chapels built during the war by the prisoners.

Siong Lim Temple (right) was officially founded in 1898 but it took 15 years for Chinese craftsmen to complete the handcrafted buildings which have recently been extensively restored. The temple was modelled after a famous temple in Fuzhou province, China. Its full name is Lian Shan Shuang Lin Shi or Twin Grove of the Lotus Mountain Temple. Strolling within its walls is like stepping back in time.

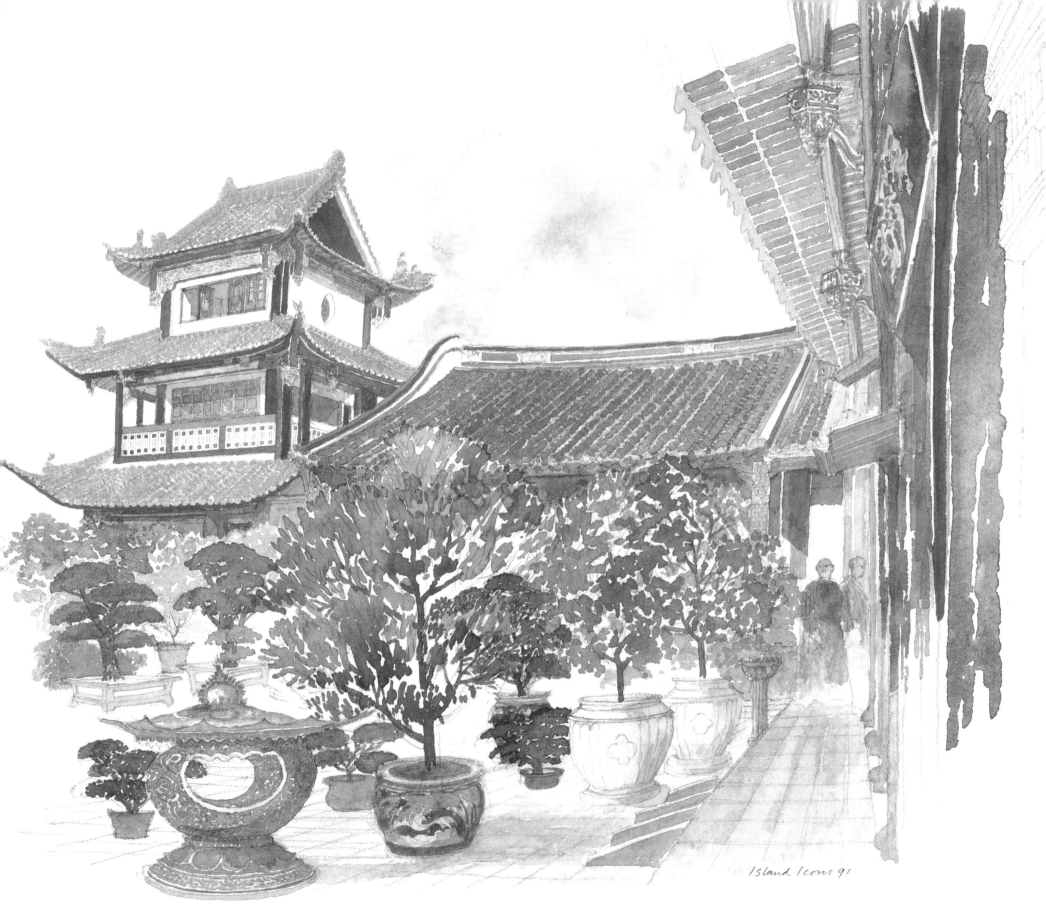

Island Icons 91

Page 16
Caldwell House, (formerly Convent of the Holy Infant Jesus), Victoria Street
Built in 1840-41. Architect: George Coleman.
Gazetted a National Monument on 26 October 1990.
In 1852 the house was purchased by Father Beurel who eventually bought all nine land lots between Victoria Street and North Bridge Road for a cloistered convent and school. When the Convent of the Holy Infant Jesus relocated to Toa Payoh, the site, including Caldwell House, became a restaurant and cultural complex known as CHIJMES.

Page 17
Empress Place Building, Empress Place
Built in 1864-65 with subsequent additions.
Architect: J.F.A McNair.
Gazetted a National Monument on 14 February 1992.
These former offices housed the Immigration Department, the Registry of Births and Deaths and the Citizenship Registry until restored in 1989 as a private exhibition venue. In 1995 it was taken over by the National Heritage Board and has been again restored and reopened as the enlarged home of the Asian Civilisations Museum.

Victoria Theatre and Concert Hall, Empress Place
Built in 1856-62 (Theatre) and 1905 (Concert Hall), with subsequent refurbishments in the mid-1950s and 1979-80.
Gazetted a National Monument on 14 February 1992.
The oldest portion is the Theatre, which opened as the Town Hall in 1862. To commemorate the Jubilee celebrations of Queen Victoria, the community decided to build a new theatre. The Town Hall was refaced and integrated with the new Victoria Memorial Hall by a 60-metre (197-foot) clock tower. The People's Action Party held its inaugural meeting on 21 November 1954 in Victoria Memorial Hall. Renovated in the late 1970s to serve as home of the Singapore Symphony Orchestra, it is now known as Victoria Concert Hall.

Page 18
Parliament House, Empress Place
Built in 1827 with subsequent alterations.
Architect: George Coleman.
Gazetted a National Monument on 14 February 1992.
The house was commissioned by a wealthy Java-based merchant, J.A. Maxwell. It was built on land designated for government use in Raffles' Town Plan It was never used as a residence, but was instead leased then acquired by the government and used as a court house and offices. In the 1950s it was converted into the Assembly Chambers and upon self-rule in 1959 became Parliament House. With the completion of the new Parliament House in 1999 it is now an arts venue.

Page 19
Istana Negara (formerly Government House), Orchard Road
Built 1867-1869. Architect: J.F.A. McNair.
Gazetted a National Monument on 14 February 1992.
Set amidst park-like grounds that are open to the public on Public Holidays, this arcaded mansion is the official residence of the President of Singapore. It was built as the residence of the Governor of the Straits Settlements by Indian convict labourers who made their own bricks and plaster.

Page 20
Asian Civilisations Museum (formerly Tao Nan School)
Built 1910-1912.
Gazetted a National Monument on 27 February 1998.
Located on quiet Armenian Street near the Armenian Church, Tao Nan School was founded by Chinese philanthropists in 1903. After the school relocated to modern premises in Marine Parade the building sat vacant until incorporated into the National Heritage Board's museum precinct.

Singapore Art Museum (formerly St Joseph's Institution), Bras Basah Road
Built in 1867 (central block), with subsequent additions.
Architect: Brother Lothaire.
Main building gazetted a National Monument on 14 February 1992; classrooms gazetted a National Monument on 3 July 1992.
St Joseph's Institution opened in 1852 in a small Catholic chapel erected on the site in 1830. The foundation stone of the present building was laid in 1855, but it was not completed until 1867 due to lack of funds. The curved wings of the main building were added by priest architect, Father Nain, around 1906. The school was relocated out of the central area and the buildings taken over by the National Heritage Board.

Page 21
Singapore History Museum, Stamford Road
Built in 1887.
Architect: Henry McCallum, Colonial Engineer.
Gazetted a National Monument on 14 February 1992.
The National Museum began life as a double entity called the Raffles Library and Museum, its primary focus being natural history. As a colonial institution, the largely British staff were mainly concerned with providing services for their compatriots. From the 1960s, the museum embarked on a programme to build collections reflecting the cultural and intellectual interests of the nation. In 1992, plans for a museum precinct were unveiled, and in 1993, the National Heritage Board was established to implement them. The National Museum is now the Singapore History Museum.

Page 22
Fort Canning Country Club, Fort Canning
Built in the 1930s as part of the general upgrading of the British armed forces in the Far East, this building is one of a pair that has been restored and injected with new life. During the period leading up to the battle for Singapore in 1942 the headquarters of what was then Malaya Command was housed in these buildings on Fort Canning.

Page 23
Central Fire Station, Hill Street
Built 1908-1909.
Gazetted a National Monument on 18 December 1998.
This style of "blood-and-bandage" buildings – alternating exposed red brick and white plastered surfaces – was popular in Edwardian England. The Central Fire Station is one of two surviving examples – the other being the MPH building on nearby Stamford Road.

Pages 24-25
Raffles Hotel, Beach Road
Opened in 1887 in a bungalow known as Beach House; first extension 1889; Palm Court Wing 1892; demolition of Beach House and construction of Main Building 1899; Bras Basah Wing 1904; Bar and Billiard Room circa 1907. Closed March 1989 for restoration and redevelopment. Reopened on 16 September 1991. Main Building and Bras Basah Wing architect: R.A.J. Bidwell of Swan & Maclaren.
Gazetted a National Monument on 6 March 1987.
Raffles Hotel opened humbly in a spacious bungalow. Under the guidance of the astute and enterprising Sarkies brothers, who also founded the Strand in Rangoon and the E&O in Penang, it expanded continuously until by 1910 the hotel as it is today was in place. It was the opening of the Main Building in 1899 that signalled Raffles' transformation from hostelry to Grand Hotel, as the building and services offered were on a scale hitherto unseen in the port city.

Page 26
Fullerton Hotel, No. 1 Fullerton Square.
Completed 1928. Architects: Keyes and Dowdeswell.
This Shanghai-based firm of architects won the open competition for the project to build a new general post office. After a painstaking restoration and conversion – including the cleaning and repair of the building's Shanghai plaster panels – the building has reopened as a deluxe hotel with a 1930s feel.

Pages 28-29
Waterloo Street Arts Housing
Waterloo Street was originally lined with bungalows built
for early European settlers. One landmark along the street
is the island's oldest Jewish synagogue, Maghain
Aboth Synagogue (1878; gazetted a National Monument
in 1998). The deliberate policy of utilising heritage buildings
as homes for arts groups has been a great success.

Page 30
Stamford House, Stamford Road
Built in 1904. Architect: R.A.J. Bidwell of Swan & Maclaren.
This three-storey building was commissioned by Seth Paul
who named it Oranje Building. During the 1920s, it
was leased by the Sarkies brothers who used it as an annex
of Raffles Hotel and christened it The Grosvenor. There
are many noticeable design similarities between it, portions
of Raffles Hotel and the Goodwood Park Hotel tower block,
as all were designed by the same architect.

Page 31
MPH Building, Stamford Road
Built in 1908. Architect: Swan & Maclaren.
This example of Edwardian commercial architecture was
built as the Methodist Publishing House headquarters in
1908. Today, it is one of Singapore's busiest bookstores,
complete with café, and an important landmark along
Stamford Road.

THE RIVER REVIVED

Page 32
**DBS Arts Centre – Home of the Singapore Repertory Theatre,
No. 20 Merbau Road, Robertson Quay**
Architect: unknown.
This classic Singapore warehouse with arched arcade has
been transformed into the permanent home of the
Singapore Repertory Theatre.

Pages 34-35
Terraced Houses, Mohamed Sultan Road
Mostly late 19th and early 20th century. Various architects.
This road has experienced several distinct periods – first,
a desirable address for Chinese towkays with businesses near
the river; then a dilapidated side street with rundown
and empty buildings; and now a very popular location
for restaurants, bars and clubs. Several of the three-storey
terrace houses along the road are more Chinese in
character and include fine examples of classic Chinese
handcrafted decorative details such as geometric carved timber
panels and painted friezes.

Pages 33, 36-37
Shophouses, Boat Quay
Gazetted a Conservation Area on 7 July 1989.
Boat Quay runs along the south side of the Singapore River
and was the location of the earliest godowns built after the set-
tlement became an East India Company outpost. Even after a
new harbour was built at Tanjong Pagar in 1852 much of the
shipping business remained concentrated around Boat Quay.
In recent years the buildings have changed hands, have been
refurbished and are now mainly restaurants, cafés and pubs.

Page 37
Shophouses and godowns, Clarke Quay
Built mostly late 19th and early 20th century. Various
architects. Gazetted a Conservation Area on 7 July 1989.
There is a pleasing symmetry to Clarke Quay that comes from
the intersection of two short roads anchored by a central space.
No longer a warehouse and factory district, Clarke Quay was
restored as a festival village in the early 1990s.

Pages 38-39
Singapore River Bridges
Cavenagh Bridge
Built in 1868-69. Architect: Public Works Department.
Named after Major-General William Orfeur Cavenagh,
Governor of Singapore 1859-1867, and built with cast iron
shipped from Glasgow by P.W. MacLellan, Engineers.

Coleman Bridge
There has been a bridge here since 1822, although it has been
improved and widened many times. It is named after the
architect and government surveyor G.D. Coleman. The present
bridge is recent and was designed to retain the architectural and
decorative features of an earlier structure.

Elgin Bridge
Elgin Bridge connects North Bridge Road and South Bridge
Road. The present bridge, which was constructed in the mid-
1920s, is the fifth on the same site for it was here that the first
bridge that crossed the river was built in 1819. That footbridge
was called Presentment Bridge, or Monkey Bridge.

SOUL OF THE CITY

CHINATOWN
Gazetted a Conservation District on 7 July 1989.

Page 40
Thian Hock Keng Temple, Telok Ayer Street
Built in 1841.
Gazetted a National Monument on 6 July 1973.

The Hokkien community built Singapore's oldest temple with
materials specially imported from China when Telok Ayer
Street fronted the sea. In conferring one of the 2001
Architectural Heritage Awards, the Urban Redevelopment
Authority (URA) acknowledged the sensitivity and success of
the recent restoration.

Page 41
Club Street
Club Street runs the length of the "hill" behind Telok Ayer,
joining Ann Siang Road at the top. The area was first known
as Scott's Hill after its owner, Mr. Charles Scott, who
cultivated nutmeg and cloves. The land was sold on to
Mr. Ann Siang, a rich sawmill owner who subdivided it.
It soon became a popular location for clan and other
Chinese associations.

Pages 42-43
Amoy Street/Telok Ayer Street
This remains a fascinating area because of the sheer variety of
buildings and activities in a relatively small space – from
historic religious buildings and wonderful examples of early
shophouse architecture, to street life and, most recently, the
arrival of advertising, Internet, legal and design firms.

Page 44
Pagoda Street
Pagoda Street was already built up by the 1860s but the
present shophouses date from the late 19th century. Like many
of Chinatown's buildings pre-restoration, these showed the
strains of decades of overcrowding and neglect. Yet their
refined details inevitably made an elegant architectural
statement. Queen Elizabeth walked down the street on her first
state visit in 1972.

Page 45
Trengganu Street
Bustling Trengganu Street is usually thought of as the heart of
Chinatown and has long held a special place in the hearts of
Singaporeans. Although restoration has brought change to the
commercial activities of the street, it is still a crowded, busy
thoroughfare well into the night.

Page 46
Bukit Pasoh Road
Bukit Pasoh boasts a concentration of shophouses built in
the 1920s and 1930s when concrete was wisely used in
their construction.

Duxton Hill
This was one of the first areas restored in its entirety. The

URA acquired the land for urban renewal and residents were moved out but then many of its buildings were vacant for years. Eventually the buildings were sold by tender and restored by their new owners according to the new conservation guidelines. The Duxton Hotel is a prominent landmark in the area.

Page 47
The Old Great Eastern Hotel (Yue Hwa Emporium) and Majestic Cinema, Eu Tong Sen Street
The wealthy Eu Tong Sen built the Art Deco cinema and hotel with cast iron details in the late 1920s. The cinema was famed for its Cantonese opera performances before being converted into a cinema. The hotel has been restored and converted into an emporium selling products from the People's Republic of China.

Shophouse, South Bridge Road
The original plan fore this three-storey structure calls it "Proposed photographer's house...the property of Lee Yin Fan esq.". Mr. Lee belonged to an extended family of photographers that operated studios throughout Southeast Asia in the late 19th and early 20th centuries.

KAMPONG GLAM
Gazetted a Conservation District on 7 July 1989.

Page 48
Shophouse, No. 321 Sultan Gate, at corner with Beach Road
This three-storey shophouse with splayed corner, streamlined details and elegant fenestration is typical of 1920s urban architecture. Beach Road was so named because it ran parallel to the beach. A series of land reclamations, the first in the 1870s-80s, moved the sea several kilometres distant.

Page 49
Shophouses, Kampong Glam
Built early 20th century.
Kampong Glam still manages to retain something of a village atmosphere. Coffee shops serve regular patrons whilst tourists explore the well-known textile shops of nearby Arab Street.

Page 50
Masjid Sultan, North Bridge Road
Built 1924-28. Architect: Swan & Maclaren.
Gazetted a National Monument on 14 March 1975.
The present Masjid Sultan replaced an earlier structure dated circa 1824 and has undergone several facelifts over the years. While there are many mosques and surau scattered around the island, Sultan Mosque continues to be a focal point for Singapore Muslims.

Page 51
Taman Warisan Melayu
Two historic buildings in Kampong Glam – the Istana Kampong Glam and the house known as Gedung Kuning – are being transformed into the Taman Warisan Melayu or Malay Heritage Centre. The old Istana, which is believed to date from the 1840s, will be a museum. Plans call for the house to become a heritage restaurant.

LITTLE INDIA
Gazetted a Conservation District on 7 July 1989.

Pages 54-55
Selegie Road
Built 1930s.
This charming Art Deco building has long been an important urban landmark as much because of the charming way it turns the corner as for its position at the intersection of several well-travelled roads – Bukit Timah, Selegie and Serangoon.

Page 56
Buffalo Road
Little India had by the 1990s developed its distinctly Indian ambience. Not only were there Indian-run retail shops, but cattle and sheep traders, butchers and dairymen drawn there because of the abundance of grass and water. Thus the origins of the name Buffalo Road are not so difficult to ascertain.

Page 58
Shophouse, Syed Alwi Road
Syed Alwi Road has several wonderful examples of shophouse architecture at its most flamboyant.

Page 59
Shophouses, Veerasamy Road
These flamboyant twins were restored in the early 1990s and dramatically anchor the junction of Veerasamy Road and Jalan Besar.

CLASSIC TERRACES

Pages 60-61
Residential terraces, Nos. 2-16 Koon Seng Road
Built in the 1920s.
Named after Cheong Koon Seng, an auctioneer and estate agent, the street is memorable in that it boasts two handsome facing rows of residential terraces near its junction with Joo Chiat Road.

Pages 62-63
Nos. 14, 15, 16 Stanley Street

These early examples of shophouses are more Chinese in flavour, with such typically Chinese details as painted scrolls, plaster friezes, bottle-green tiles, and granite columns.

Page 65
Nos. 61-69 Syed Alwi Road
Built circa 1920.
The oval shaped windows are unique among Singapore's shophouses and bear striking resemblance to windows in Victoria Concert Hall.

Pages 64, 66-67
Residential Terraces, Emerald Hill
Emerald Hill was gazetted a Conservation Area on 7 July 1989.
Emerald Hill has been well documented by various researchers, especially retired architect Lee Kip Lin. No. 77 Emerald Hill Road (page 67) was built for Low Koon Yee who belonged to a well-established Teochew Straits Chinese family. Until 1990 descendants of the original owner lived in the house. The new owner restored the interior with a remarkable attention to detail. No. 45 Emerald Hill (page 64) was built in 1903 by M. T. Moh and recently restored. It has a distinct Chinese entrance gate with a Chinese roof.

Page 68
Residential Terraces, Nos. 10-44 Petain Road
Built early 1930s. Architect: J.K. Jackson for Mohamed bin Haji Omar.
Gazetted a Conservation Area on 25 October 1991.
This row of 18 ornate, heavily tiled, pastel-painted terraced houses is among the most homogeneous and intact. The use of glazed ceramic tiles is particularly lavish, and the colour scheme is reminiscent of Straits Chinese porcelain, sarong kebayas and beadwork.

Page 69
Shophouse façade, Desker Road
Built 1900-1915.
This fine example of early 20th century shophouse architecture illustrates the endless creativity of the architect in combining elements of east and west and imbuing them with a distinctly local flavour. From the festoons to the fretwork, from the cast-iron balustrades and fanlights, to the decoration on the timber shutters, the composition is familiar and yet distinct.

Pages 70-71
Residential Terraces, Blair Road
Blair Road was gazetted a Conservation Area on 25 October 1991.
The beautiful residential terraces that line both sides of Blair

Road were built in the 1920s as part of the general expansion of the town. Blair Road was laid out in 1900 and is named after John Blair, a senior officer of the Tanjong Pagar Dock Company in the 1880s. During the 1990s new owners restored many of the terraces here and in the neighbouring streets, thereby creating a renewed sense of prosperity and community.

ISLAND ICONS

Page 72
Sun Yat Sen Villa, Tai Gin Road
Built in the 1880s with renovations in 1938, 1965 and 2000-2001.
Gazetted a National Monument on 28 November 1994.
The Singapore branch of the Tung Ming Hui was headed by Dr Sun Yat Sen who plotted the overthrow of the Manchu Dynasty. Dr Sun, who became the first provisional President of the Republic of China, stayed here on several occasions in the early 20th century. Recent renovations have upgraded the museum, which is maintained by the Singapore Chinese Chamber of Commerce and Industry.

Page 73
Coffee Shop, Balestier Road
This is a varied and interesting street with medical clinics and building material suppliers, old-fashioned provision and medicine shops, fruit stalls and coffee shops. The road was named after Joseph Balestier who in 1836 was appointed the first American Consul to Singapore. He owned a large sugar plantation called Balestier Plain.

Page 74
Goodwood Park Hotel Tower Block, No. 22 Scotts Road
Built in 1900. Architect: R.A.J. Bidwell of Swan & Maclaren.
Gazetted a National Monument on 23 March 1989.
Built by the German community as their Teutonia Club, the building was confiscated by the colonial authorities during World War I when all German residents were interned. Post-war, the building was reopened as a venue for concerts, talks, film shows and receptions by the Manasseh brothers who named it Goodwood Hall, and it was here in 1922 that Anna Pavlova danced. Since 1929, it has been the Goodwood Park Hotel.

Commercial buildings, Orchard Road
Built in the 1920s.
Originally plantation land and then a popular site for villas, tree-lined Orchard Road was frequently compared to picturesque British lanes by early travellers. Its transformation into a commercial area began in earnest in the early years of the 20th century and, since then, frequent redevelopment has been the norm. This row is the only visual reminder of Orchard Road before the days of shopping malls.

Page 75
House of Tan Yeok Nee, No. 101 Penang Road
Built in 1885.
Gazetted a national monument on 29 November 1885.
Now a campus for the University of Chicago Graduate School of Business, this traditional Chinese Chou Zhou-style courtyard house has been beautifully restored so that the original architecture and character are intact. The only example of a traditional Chinese courtyard style house remaining in Singapore, it was built for the businessman Tan Yeok Nee. For many years it was the Salvation Army headquarters. Of particular interest are the unique shapes of the gable end walls.

Telok Ayer Market (Lau Pa Sat), Robinson Road
Built in 1894. Architect: Municipal Council of Singapore with cast iron supplied by William MacFarlane of Glasgow.
Gazetted a National Monument on 6 July 1973.
There has been a market on this site since 1824. The present elegant Victorian structure was designed by Municipal Engineer James MacRitchie, after whom MacRitchie Reservoir is named. The ornamental cast iron was manufactured by William MacFarlane & Co. of Glasgow. After renovations in the 1970s, it became a popular food centre. During construction of the Mass Rapid Transit railway, the structure was dismantled, then reinstated. It was then turned into a Festival Market.

Pages 76-77
Singapore Improvement Trust flats, Tiong Bahru
Built 1930s.
The Singapore Improvement Trust was formed in 1927 to "provide for the Improvement of the Town and Island of Singapore". Between 1936 and the fall of Singapore it completed just over 2,000 units including these blocks in Tiong Bahru which were the first phase of a new town. All SIT 1930s buildings bore the stamp of the Modern Movement in their flat roofs, curved balconies and stairwells, horizontal ribbon windows and white cubist look.

Page 78
Shophouses, Joo Chiat Road
Joo Chiat was gazetted a Conservation Area on 23 July 1993.
Joo Chiat Road still has the feel of a small town main street and includes many fine examples of shophouse architecture. The Red Bakery on East Coast Road was long a landmark, with its traditional coffee shop tables and chairs, old-fashioned pastries and coffee and tea served in thick mugs.

Page 79
Suburban terraces, corner of Lorong 19 and Lorong Bachok, Geylang
Built circa 1929.
Geylang was gazetted a Conservation Area on 25 October 1991.
Sikh guards – in plaster – stand at attention at the corner entrance to this elaborate and utterly unique concoction. The scenic panels beneath the upper storey windows depict scenes ranging from a rickshaw ride and a soccer match to Chinese classical tales.

Pages 80-81
Old Tanglin Officers' Mess, Tanglin Road
Built 1930s.
Tanglin was developed into a barracks area for British army troops in 1868 and the Officers' Mess was built on what was then known as Mount Harriet. The first troops moved into the site in 1872 and from then until the fall of Singapore in 1942 the barracks remained the home of the British garrison infantry battalion. The Officers' Mess building is a 1930s rebuild of the earlier structure on the site. After restoration and the addition of an office building behind, it is now the permanent home of the Ministry of Foreign Affairs.

Pages 82-83, 85
Black-and-White Houses, Goodwood Park, Botanic Gardens, Ridley Park and Alexandra Park
Built 1900-1930. Architects: colonial engineers and the Public Works Department.
These houses were built mainly for colonial administrators and senior army officers and planned within a park-like setting. The architecture combined nostalgic memories of Tudor cottages with an excellent understanding of the tropical climate and sensitivity to vernacular Malay architecture. The half-timber construction is generally confined to the second storey while the first storey has load-bearing brick walls, piers and columns.

Page 84
Eden Hall, Residence of the British High Commissioner, Nassim Road
Built in 1904.
Eden Hall was built in the late Edwardian Classical Revival style for the wealthy Jewish businessman E.S. Manasseh. Manasseh leased the house to a Mrs. Campbell who ran it as a boarding house, then moved into it in 1918 and lived there until his death in 1945. There is a splendid dining room and a delightful garden room that overlooks a paved terrace. In 1993 renovation works revealed a cast-iron balustrade along the main staircase emblazoned with the letter M.

Page 86
Alkaff Mansion, Telok Blangah Green
The Alkaffs were a wealthy and prominent Arab trading
family originally from South Yemen who built this
hilltop house as a family retreat and to entertain
guests. Abandoned after World War II, it fell into disrepair
and was rediscovered and acquired by the Singapore
Tourist Promotion Board in 1986. Restored, it is now
a restaurant and venue for functions in the manner of a
grand old home.

Bungalow, Mountbatten Road
Built circa 1910.
A typical example of the early 20th century suburban bungalow
built for well-to-do Chinese families in areas like Katong. At
one time, there were many such suburban bungalows but these
have given way to more intensive development.

Page 87
Golden Bell (Danish Seaman's Church), No. 9 Pender Road
Built in 1909. Architect: Moh Wee Teck.
Located on a hill once known as Mount Washington,
Golden Bell was commissioned by Tan Boon Liat, the
grandson of Tan Tock Seng who was an early leader of
the Hokkien community and benefactor of the hospital
that bears his name. It is now the Danish Seaman's Mission.

Page 90
**Changi Chapel and Museum, No. 1000 Upper Changi
Road North**
Built in 2000.
This gem of a museum outside the walls of the old
Changi Prison is dedicated to the experience of the
Prisoners of War interned during the Japanese Occupation
of Singapore. The museum is a square with an internal
courtyard devoted to a simple outdoor chapel with
timber benches designed in the spirit of the makeshift
chapels in which the prisoners held their services.

Pages 90-91
Siong Lim Temple, Jalan Toh Payoh
Constructed 1908-1912. Architect unknown.
Restored 1991-2001.
Gazetted a National Monument on 17 October 1980.
Conceived by Fujian businessman Low Kim Pong and
patterned after a famous temple in Fuzhou province, China,
Siong Lim Temple is symmetrical in plan with buildings
arranged along a central axis separated by courtyards. The
compound was a major tourist attraction in the early 20th
century but gradually fell into shabby disrepair. A massive
10-year restoration programme with craftsmen brought from
China commenced in 1991.

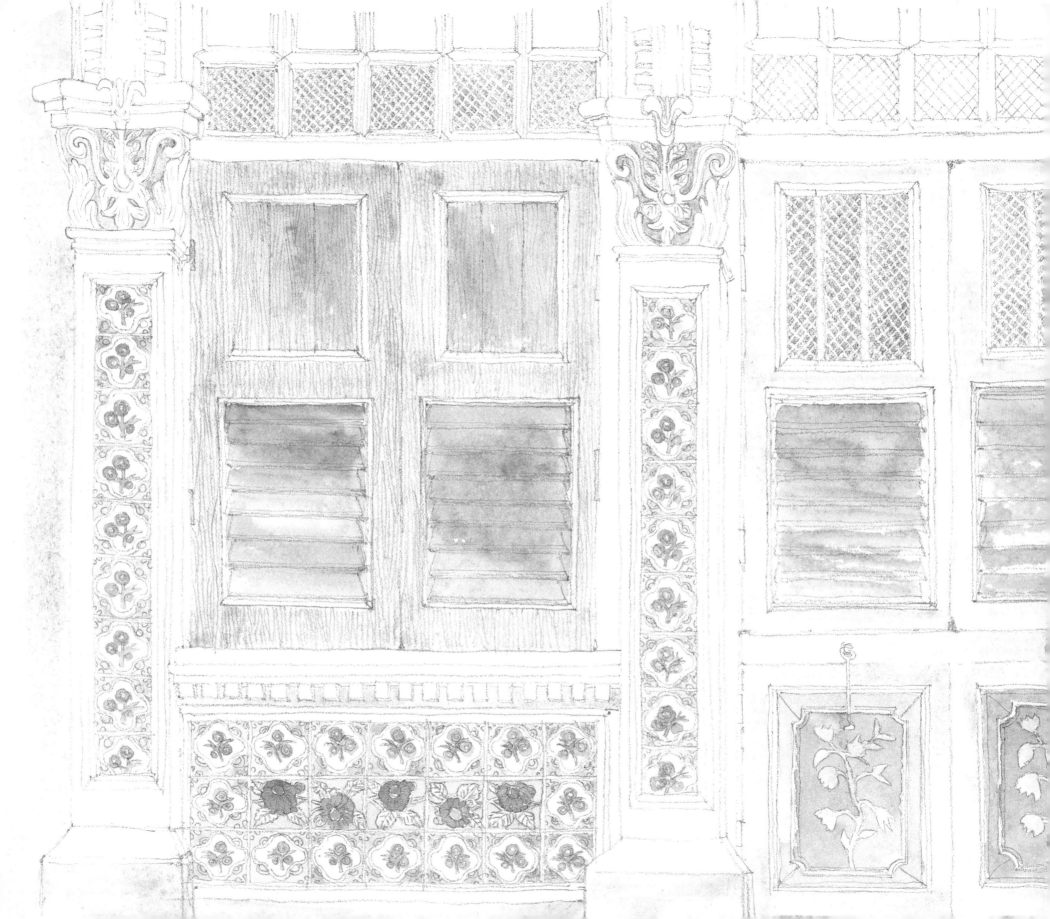